New Complete History Workbook

Charles Hayes

Gill & Macmillan

Gill & Macmillan L...
Hume Aven...
Park ...
D...
with associated c...

Artwo... ...Allsopp
Print Origina... ...h Image, Dublin

eTest.ie – what is it?

A revolutionary new website-based testing platform that facilitates a social learning environment for Irish schools. Both students and teachers can use it, either independently or together, to make the whole area of testing easier, more engaging and more productive for all.

Students – do you want to know how well you are doing? Then take an eTest!

At eTest.ie, you can access tests put together by the author of this textbook. You get instant results, so they're a brilliant way to quickly check just how your study or revision is going.

Since each eTest is based on your textbook, if you don't know an answer, you'll find it in your book.

Register now and you can save all of your eTest results to use as a handy revision aid or to simply compare with your friends' results!

Teachers – eTest.ie will engage your students and help them with their revision, while making the jobs of reviewing their progress and homework easier and more convenient for all of you.

Register now to avail of these exciting features:

- Create tests easily using our pre-set questions OR you can create your own questions

- Develop your own online learning centre for each class that you teach

- Keep track of your students' performances

eTest.ie has a wide choice of question types for you to choose from, most of which can be graded automatically, like multiple-choice, jumbled-sentence, matching, ordering and gap-fill exercises. This free resource allows you to create class groups, delivering all the functionality of a VLE (Virtual Learning Environment) with the ease of communication that is brought by social networking.

Contents

★ **1** (a) What is a primary source as used by a historian?

(b) Name two types of primary sources that a historian can use.

(i) _____ (ii) _____

★ **2** (a) What is a secondary source? _____

(b) Give an example of a secondary source. _____

★★ **3** In the case of each example of a source given below, put an ✘ in the correct box to indicate whether it is a primary or a secondary source. One ✘ has been entered already.

Example of a source	Primary source	Secondary source
● An eyewitness account	✘	☐
● A modern biography of Julius Caesar	☐	☐
● An autobiography	☐	☐
● A school textbook in History	☐	☐
● A photograph	☐	☐
● A census	☐	☐

4 Name two types of written sources that historians use when finding out about the past.

(i) _____ (ii) _____

★ **5** Give one reason why historians prefer to obtain information from more than one source.

★ **6** State what a student of history might learn from a visit to each of the following:

- An art gallery: _____

- A museum: _____

7 In relation to the study of history, write down the meaning of each of the following:

Archive: _____

Bias: _____

Oral history: _____

Propaganda: _____

★ **8** What is the main difference between history and archaeology?

★ **9** (a) What is an artefact? _____

(b) Give an example of an artefact. _____

10 What is meant by the term 'prehistory'? _____

★ **11** Name two instruments an archaeologist would use while excavating a site.

(i) _____

(ii) _____

★ **12** What is meant by the letters BC and AD attached to dates?

BC: _____

AD: _____

★ 13 People in history

You may be asked in your Junior Certificate examination to write accounts of certain people in history. A commonly asked question, for example, is to 'describe an archaeologist at work'. To score full marks on this question at Higher Level you will need to make **at least eight full and clear points** on the subject. You should also lay out your answer clearly and in paragraphs.

In the box below write on the subject of **an archaeologist at work**. Two points have already been made to start you off.

To find out about the past, an archaeologist will make use of artefacts, which are things that have been made or used by people in the past. ✓

The archaeologist will first search for a suitable site in which to search for artefacts. ✓

★ **1** (a) Name an ancient civilisation outside Ireland. _____

(b) Describe primary and secondary sources that give us information about that civilisation.

★★ **2** Describe **food** and **clothing** in ancient civilisations:

Food

Clothing

3 Write an account of different types of **work** that people did in Ancient Rome.

4 Using historical sources

Read the passage in Source 1 below and answer the questions on the next page.

Blood sports – Ancient Roman style

The games began with the great procession. To the roar of the crowd the gladiators marched past the enclosed area where the Emperor sat. With the gladiators marched musicians, priests, jugglers, clowns and swaying dancers.

The animal shows came next. Exotic beasts from the far reaches of the Empire were first displayed to the crowd. Then some animals were made to fight each other. A beautiful bull elephant was so injured by a pair of lions that the attendants had to spear him to death. His blood soaked into the sand that covered the floor. Large jars of incense burned sweetly around the sides of the arena. They helped to keep the sticky smell of blood from the noses of the important people who occupied the front seats.

After the animal fights, there was some light entertainment – the only bit of the day that I enjoyed. There were jugglers and dancers and clowns who pretended to fight like gladiators. Many in the crowd were now devouring a prandium (lunch) of bread washed down with wine. Some (who had taken too much wine) were beginning to sing and chant noisily and to scream for the upcoming main attraction of the day – the gladiator contests.

After several gladiator fights, the sandy floor had to be raked to cover numerous clots of slippery blood. The final contest was between two different types of gladiator – a murmillo fighter using a sword and shield and a retiarius using a net and trident. Both gladiators were wounded and exhausted when the brave murmillo fell and let the sword slip from his grip. The contest was over. I was horrified to see the sweaty crowd give the thumbs-down sign and bay for the blood of the defeated fighter. An attendant – dressed as Charon, the Ferryman – struck the murmillo on the head with a large mallet. The crowd was already beginning to head for the exits when, to the blast of trumpets, the dead man's body was dragged from the arena.

(a) How did the Romans cope with the blood spilt during the games?

(b) There were different types of gladiators. Briefly contrast a *murmillo* with a *retiarius*.

(c) Referring to the text, give two pieces of evidence that the writer disapproves of the games described.

(i) _____

(ii) _____

(d) The attendant who killed the *murmillo* was dressed as 'Charon the Ferryman'. Write anything you have learned in your textbook about Charon.

(e) In which building in Rome would you expect the games described to have taken place?

5 **Would you believe it?**

Read the statements below. Guess whether each statement is correct or incorrect. Then read the upside-down writing in the small box below to find out how many of your guesses were right.

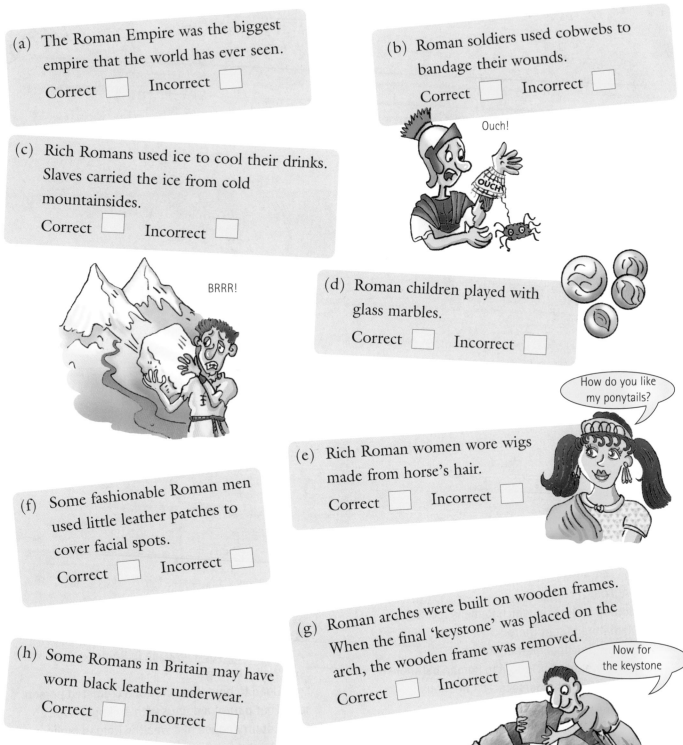

(a) The Roman Empire was the biggest empire that the world has ever seen.

Correct ☐ Incorrect ☐

(b) Roman soldiers used cobwebs to bandage their wounds.

Correct ☐ Incorrect ☐

Ouch!

OUCH

(c) Rich Romans used ice to cool their drinks. Slaves carried the ice from cold mountainsides.

Correct ☐ Incorrect ☐

BRRR!

(d) Roman children played with glass marbles.

Correct ☐ Incorrect ☐

How do you like my ponytails?

(e) Rich Roman women wore wigs made from horse's hair.

Correct ☐ Incorrect ☐

(f) Some fashionable Roman men used little leather patches to cover facial spots.

Correct ☐ Incorrect ☐

(g) Roman arches were built on wooden frames. When the final 'keystone' was placed on the arch, the wooden frame was removed.

Correct ☐ Incorrect ☐

Now for the keystone

(h) Some Romans in Britain may have worn black leather underwear.

Correct ☐ Incorrect ☐

Statements (a) and (e) are incorrect. All others are correct.

6 A Roman word puzzle . . .

. . . for you to enjoy!

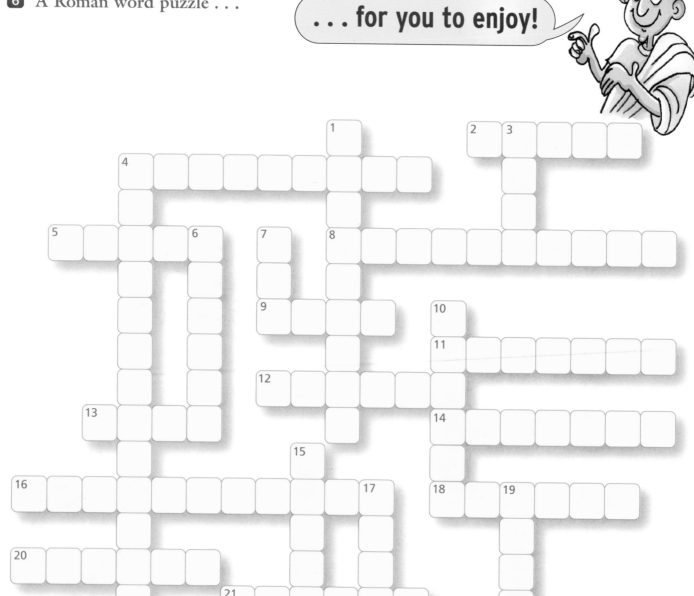

Clues Across:

2 Modern country in which Rome is located.
4 Gladiators fought there.
5 Rome's principal market place.
8 Warm (not too hot) room in Roman bathhouse.
9 An emperor who persecuted Christians.
11 Writer of ancient Rome.
12 Craftsperson who made barrels.
13 God of War.
14 Apartment blocks in ancient Rome.
16 Enclosed garden or patio in domus.
18 Picture made of tiny pieces of glass or pottery.
20 River on northern boundary of Roman Empire.
21 They did most of the work in ancient Rome.

Clues Down:

1 Leader of a century in the Roman army.
3 Would be worn by a male citizen of Rome.
4 Venue for chariot racing in Rome.
6 Wall paintings.
7 Used to hold the ashes of a cremated person.
10 That part of a domus with an impluvium.
15 Country house of a wealthy Roman family.
17 Might be stuffed at a Roman feast.
19 River that leads to Hades.

★★ **1** Why are early times called the *Stone Age*? _____

★ **2** Archaeologists sometimes describe the earliest Irish
people as *hunter-gatherers*. What is meant by that term? _____

3 Examine the picture of a model of a Neolithic
house in Source 1.

(a) What does the term *Neolithic* mean?

(b) Briefly describe the walls and roof of the
house.

★ (c) Why do you think the fence shown in the picture
would have been built around a Neolithic house? _____

★ **4** What is a *megalith*? _____

★ **5** Name three types of megalithic tombs that existed in Neolithic Ireland.

(i) _____ (ii) _____ (iii) _____

★ **6** Which one of the following is a site associated with Stone Age Ireland? (Circle the correct option)

Newgrange Jerpoint Abbey Wood Quay

★ **7** Source 2 shows Poulnabrone dolmen.

(a) What name is given to the stone marked **X**?

(b) Why did Stone Age farmers build structures like this?

(c) Give two reasons why that period was called the Stone Age.

(i) _____

(ii) _____

8 Source 3 shows Stone Age people building a tomb similar to that shown in Source 2 above. Using Source 3, describe the following:

(a) How large stones were brought to the tomb site: _____

(b) How vertical (portal) stones were put in place: _____

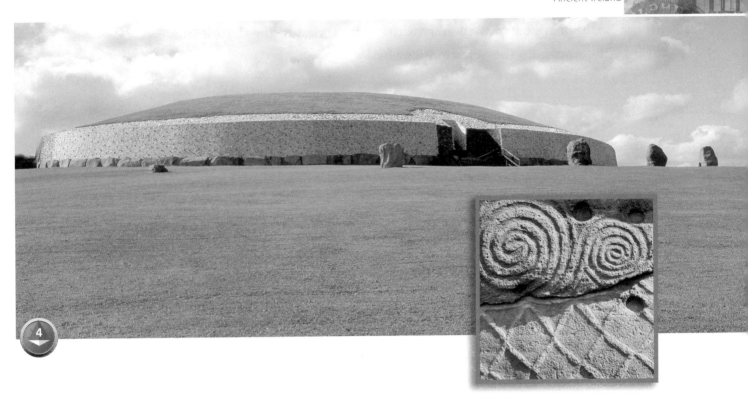

9 Examine the picture of a Stone Age tomb in Source 4.

(a) Where do you think this picture was taken? _____

(b) What type of tomb is shown? _____

★ (c) What evidence exists in the picture that the builders of the tomb were very skilled?

10 In the boxes provided match each letter in Column X with the number of its pair in Column Y.
One match has been completed for you.

	Column X			Column Y			
A	Standing stones	1	Circular grinding stones		A	4	
B	Lunula	2	Metal used by Celts		B		
C	Fulacht Fia	3	Copper and tin		C		
D	Cist grave	4	Drombeg		D		
E	Bronze	5	Bronze Age cooking site		E		
F	Rotary quern	6	Poulnabrone		F		
G	Portal dolmen	7	Moon-shaped gold necklace		G		
H	Iron	8	Rectangular pit		H		

11 In the boxes provided write the **terms** that correspond to the **definitions**.
Select the terms from the Selection Box below.

Terms

Definitions:

1 []
A Neolithic tomb that contained an open area and one or more burial chambers.

2 []
A Bronze Age gold necklace or bracelet in the form of a rope.

3 []
Ireland's first people.

4 []
A Celtic festival to mark the beginning of summer.

5 []
Another word for a circular stone fort.

6 []
A form of ancient writing found inscribed in standing stones.

7 []
A technique used in ancient Ireland in the building of walls and houses.

8 []
A small Celtic kingdom in ancient Ireland.

9 []
The ruler of a Celtic kingdom in ancient Ireland.

10 []
The successor to a Rí.

11 []
A Celtic custom that involved the education of children outside their homes.

12 []
A Celtic priest and foreteller of the future.

13 []
A poet in Celtic Ireland.

14 []
A person who recited or sang poetry in Celtic Ireland.

15 []
A Celtic judge and expert in the Brehon Law.

The definitions of all of these terms have been examined in Junior Certificate examinations.

Selection Box

- Bealtaine
- brehon
- file
- bard
- fosterage
- Tánaiste
- druid
- Rí
- wattle and daub
- dún
- torc
- hunter-gatherers
- court cairn
- ogham
- tuath

Test Yourself
eTest.ie

EARLY CHRISTIAN IRELAND

1 Choose some places from the Selection Box to identify each of the early Christian monastic sites listed below.

(a) The site of St Kevin's monastery _____

(b) A monastic site off the coast of Kerry _____

(c) The site of a monastery founded by St Declan _____

(d) The site of an island monastery in Scotland _____

(e) A monastic site near the home of an Ulster king _____

(f) A monastic site near to Ireland's biggest river _____

Selection Box
- Inishbofin
- Armagh
- Iona
- Cloyne
- Skellig Michael
- Clonmacnoise
- Tallaght
- Ferns
- Glendalough
- Ardmore

★★ **2** In the box provided, describe the main features of a monastery in early Christian Ireland. In your answer explain the terms *oratory*, *beehive cell*, *scriptorium*, *refectory* and other features.

3 Examine Source 1, which is an artist's impression of an early Christian monastery:

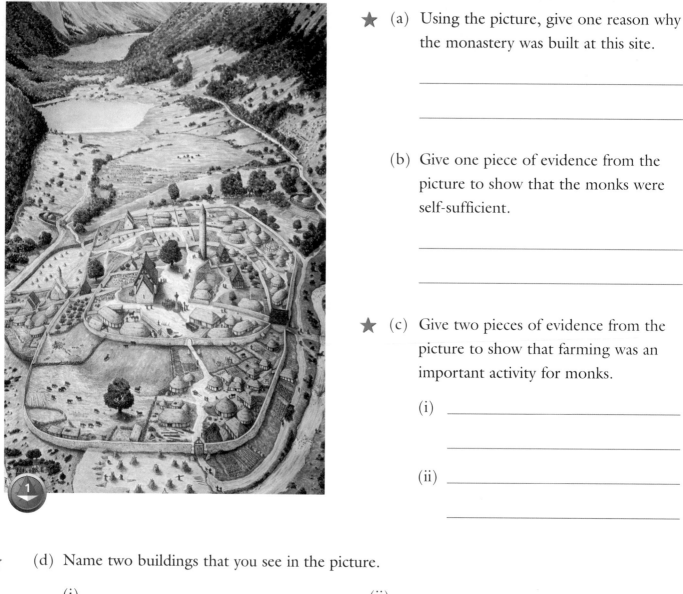

★ (a) Using the picture, give one reason why the monastery was built at this site.

(b) Give one piece of evidence from the picture to show that the monks were self-sufficient.

★ (c) Give two pieces of evidence from the picture to show that farming was an important activity for monks.

(i) _____

(ii) _____

★ (d) Name two buildings that you see in the picture.

(i) _____ (ii) _____

★ (e) Name two famous monks from the early Christian period who travelled as missionaries to Britain or Europe.

(i) _____ (ii) _____

★ (f) Mention two ways in which monasteries in Early Christian Ireland promoted education and craft.

(i) _____

(ii) _____

4 Examine the picture in Source 2.

(a) What kind of building is shown?

(b) Give two reasons why this building was erected.

(i) _____

(ii) _____

(c) Give one reason why such buildings were often in isolated places.

(d) Why do you think the entrance was so high off the ground?

Entrance

2

Source: www.antrimtown.co.uk

(e) Name one place in Ireland where an example of this type of building still survives.

(f) Mention two effects of the coming of Christianity to Ireland.

(i) _____

(ii) _____

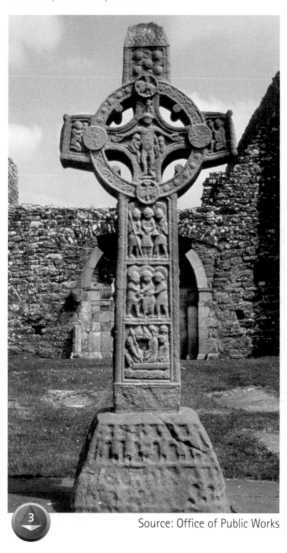

Source: Office of Public Works

5 Source 3 shows a high cross.

★ (a) What was the usual subject matter of the carvings on high crosses such as the one shown?

★ (b) Name an early Christian site in Ireland where you would find a high cross.

(c) What do high crosses such as this one tell us about the monks who made them?

6 Examine the picture in Source 4.

★ (a) Name the object shown. _____

★ (b) For what purpose do you think the object was used?

★ (c) Do you think this object would have been originally kept in: (Tick the correct box)

A castle ☐

A monastery ☐

A crannóg ☐

★ (d) Give one piece of evidence from the picture to show that skilled craftsmen made the object.

7 Examine the pictures **A** and **B** in Source 5.

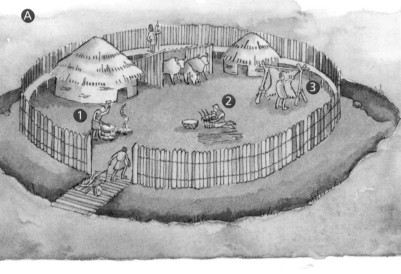

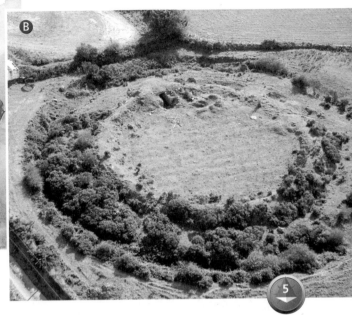

★ (a) Name one defensive feature in the ring fort shown in picture A.

★ (b) What defensive feature can be seen in picture A that has disappeared from the ring fort in picture B?

★ (c) In your opinion, what has been the main cause of damage to the ring fort shown in picture A?

★ (d) Briefly describe the type of work being done by the person labelled **1**, the person labelled **2** and the person labelled **3** in picture A.

1. _____

2. _____

3. _____

(e) Name one ancient Irish dwelling other than a ring fort.

★ **8** Put the following periods of history in correct order. Start with the earliest period.

- Iron Age • Stone Age • Early Christian period • Bronze Age

1 [] 2 []

3 [] 4 []

9 Examine the drawing of an ancient lake dwelling in Source 6.

6

(a) What name is given to this type of dwelling? _____

★ (b) Give one reason why this dwelling was built on a lake.

★ (c) How did inhabitants get from this dwelling to and from the mainland?

★ (d) Name two materials used in the building of this dwelling.

(i) _____ (ii) _____

(e) Describe how the outer wall of the dwelling was built.

10 **Puzzle it out!**

Fill the empty spaces in the five **cartwheels** to spell five types of buildings that could be found in an early Christian monastery in Ireland. The buildings might be set in a clockwise or in an anti-clockwise way. The names of these buildings are also hidden in the **wordsearch** box. Can you find and highlight them?

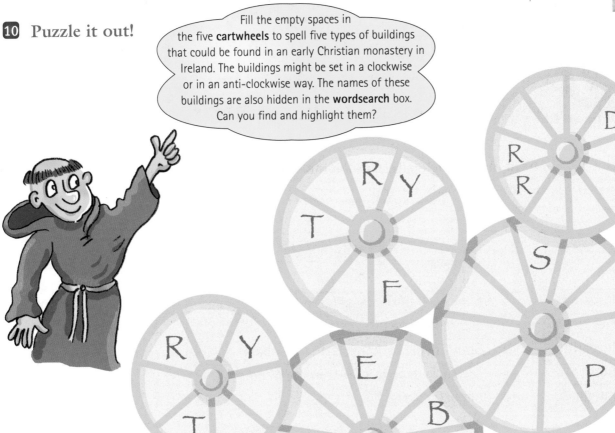

TSCRIPTORIUMERRTY
ZAYEOOAZYTSULERIL
TBTFSPSMNLSTSWAEN
IBEEHIVEHUTSSOZIA
VVLCAXSPSRYXRTSPS
XELTYDMNLYYEYDMNL
LYROTARORRTYXNTYX
PBPRTSCRTSWUPUAYE
MYMYZAYETPSTMOSPS
UUTSSTYXSNLSURMNL
XSPSMNLSTSWXELTZI

chapter 5 THE MIDDLE AGES

1 In the boxes provided, match each letter in Column X with the pair of its number in Column Y. One match has already been made for you.

Column X	
A	Feudalism
B	Jousting
C	Fief
D	Investiture
E	Serf
F	Knight

Column Y	
1	A large parcel of land
2	A member of the lesser nobility
3	A ceremony
4	Sport involving knights on horseback
5	The form of government in the Middle Ages
6	Almost a slave

X	Y
A	5
B	
C	
D	
E	
F	

★ **2** What was a knight's main job? _____

3 From your study of the Middle Ages, briefly describe three stages in the training of a knight.

(i) _____

(ii) _____

(iii) _____

4 Examine Source 1, which is a drawing of a motte and bailey castle.

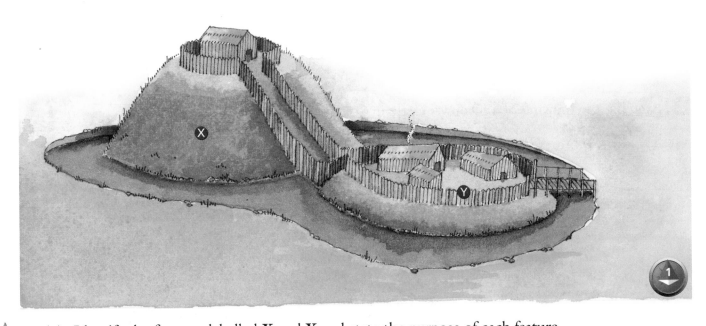

★ (a) Identify the features labelled **X** and **Y** and state the purpose of each feature.

X _____

Y _____

★ (b) Name two materials used in the building of motte and bailey castles.

(i) _____ (ii) _____

★ (c) Describe one source of evidence that an archaeologist would need in order to make a drawing like the one shown.

★ (d) State what you consider to be the most serious danger to the conservation of a historic site such as the one shown. Support your answer by evidence from the picture.

★★ (e) Give one reason why most motte and bailey castles in Ireland were built in the south-east of the country.

★ 5 Mention two reasons why Normans changed from building castles in wood to building castles in stone.

(i) _____

(ii) _____

6 Examine the drawing of a medieval castle in Source 2.

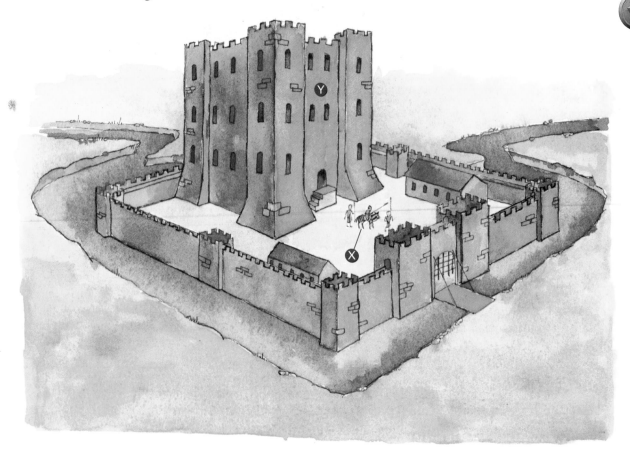

★ (a) Using evidence from the drawing, give one reason why the castle was built at this place.

★ (b) What type of person is shown on horseback in **X**? _____

★ (c) Why do you think the lord of the castle lived in the building marked **Y**?

★ (d) Give one reason why the windows in medieval castles were made so narrow.

7 **Picture and word puzzle**

Use the labelled parts of the pictures as clues to complete the word puzzle.

8 Explain briefly the meaning of each of the following terms from the Middle Ages:

★★ ● **Serf** _____

★ ● **Vassal** _____

★ ● **Manor** _____

★ **9** Give two reasons why medieval peasants lived under constant threat of famine.

(i) _____

(ii) _____

10 Historians have more information on life in medieval castles than they have on life in the house of a medieval peasant. Suggest two reasons why this is so.

(i) _____

(ii) _____

★ **11** Explain each of the following terms that relate to the Middle Ages.

● **Toll** _____

● **Charter** _____

● **Masterpiece** _____

12 Examine the picture of a medieval city in Source 3.

(a) Identify the farm work being done by each of the people labelled **A**, **B** and **C**.

A _____

B _____

C _____

(b) The picture in Source 3 is a primary source of medieval history. What does that tell you about the picture?

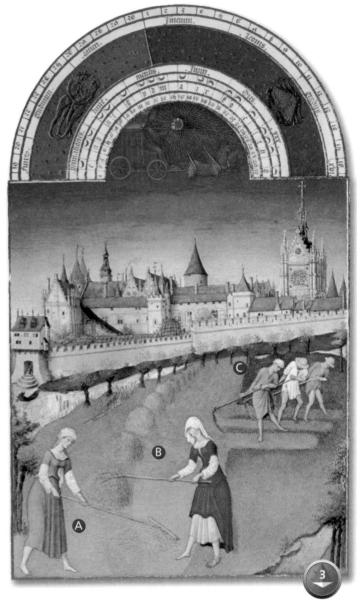

(c) Name two medieval defensive features shown on the picture.

(i) _____ (ii) _____

(d) How does the picture suggest that Christianity was important during the Middle Ages?

(e) Name two types of places in which medieval towns and cities grew.

(i) _____

(ii) _____

13 The pictures **A** and **B** in Source 4 show an archaeologist's sketches of a medieval house that once existed in Dublin.

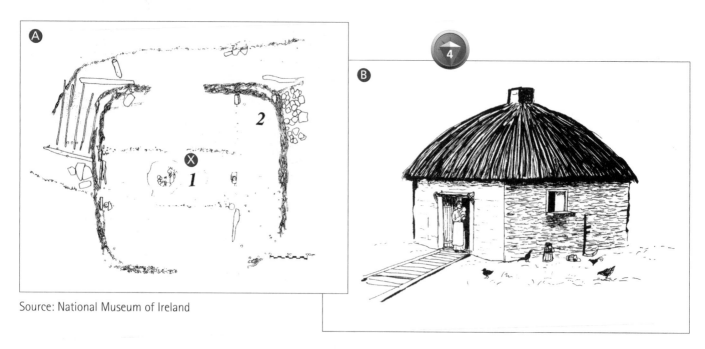

Source: National Museum of Ireland

★ (a) What part of the house is labelled **X**? _____

★ (b) Name two materials that would have been used in the building of this house.

 (i) _____

 (ii) _____

★ (c) The area around the house must have been wet and muddy in wintertime.
 What evidence in picture **B** supports this idea?

★ **14** (a) In a medieval town, what was a *guild*? _____

 (b) State two functions of a guild.

 (i) _____

 (ii) _____

15 (a) Name four medieval crafts shown by the pictures in Source 5.

1 _____

2 _____

3 _____

4 _____

(b) Give one reason why the trade shown in picture **X** was important in the Middle Ages.

Source: www.corbis.com

★ (c) Give one reason why there were so few female craftworkers in the Middle Ages.

★ **16** (a) What is the name given to the type of punishment that is shown in Source 6?

(b) Describe *two other* forms of medieval punishment for crime.

(i) _____

(ii) _____

This is an extract from an account by the famous Italian writer, Giovanni Boccaccio. He lived in Florence. He describes the outbreak of the disease the Black Death in 1348.

'It began both in men and women with certain swellings in the groin or under the armpit. They grew to the size of a small apple or egg, more or less, and were called tumours. In a short space of time these tumours spread all over the body. Soon after this the symptoms changed and black or purple spots appeared in the arms or thighs or any part of the body, sometimes a few large ones, sometimes many little ones. No medicine could overcome or ease this disease. Either the disease was such that no treatment was possible or that doctors were so ignorant that they did not know what caused it. In any case, very few recovered; most people died within three days of the appearance of the tumours described above.

The sick communicated the disease to the healthy who came near them. To speak to or go near the sick brought infection. Moreover, to touch the clothing or anything else the sick had touched or worn gave the disease to the person touching.

One citizen avoided another, hardly any neighbour troubled about others. Relatives never or hardly ever visited each other. Brother abandoned brother, and the uncle his nephew, and the sister her brother, and very often the wife her husband. What is even worse and nearly incredible was that fathers and mothers refused to see and tend their children, as if they had not been theirs.'

Source: Giovanni Boccaccio, *The Decameron*, I, Read Books 2006; and Junior Certificate, Ordinary Level.

7

17 In the Middle Ages, what was the *Black Death*?

18 **The Black Death – interpreting historical sources**

Read the document in Source 7 and answer the questions that follow:

★ (a) Where were the first swellings to be found?

★ (b) Give one reason why doctors could not help the sick.

★ (c) Give two means by which the disease spread from the sick to the healthy.

(i) _____

(ii) _____

★ (d) From the account, give two pieces of evidence to show the effects of the plague on families.

(i) _____

(ii) _____

★ 19 Medieval towns and cities – interpreting historical sources

Read the document in Source 8 and use information in it to explain how some medieval cities became wealthy and powerful.

Answer this question under **four different headings**. Under each heading:

- Make a point or statement.
- Develop the statement briefly.
- Mention one medieval city.

One heading has been completed for you.

(i) Defence features, such as castles or strong town walls, helped to make some cities important. People migrated into walled cities for protection in times of war. The building of Dublin Castle helped to make Dublin a powerful centre of Norman and British rule.

(ii) _____

(iii) _____

(iv) _____

8 The Middle Ages were so plagued by private wars that defence and security played an important role in the growth of medieval towns and cities. The presence of strong walls or of a well-defended castle (such as that at Trim, Co. Meath) encouraged country freemen to migrate to the relative safety of towns. The growth of medieval Dublin can be traced to the building of Dublin Castle. This castle contributed to the continued importance of Dublin, by becoming the headquarters of Norman and British rule in Ireland for seven hundred years.

Trade guilds and merchant guilds helped to create wealth in many medieval cities. Some cities became famous for particular branches of trade. Florence, for example, was known throughout Europe for its banking, which was controlled largely by the enormously wealthy Medici family. Trade made Florence so wealthy and powerful that the city even created its own currency (money) called the florin.

At weekly markets, held in market squares, local country people sold farm produce and brought goods made by the towns' craftspeople. There were also large-scale fairs, held usually once a year and in fair greens just outside the towns. Some European fairs lasted for weeks and attracted traders from distant lands. Imported figs and grapes, for example, were on sale in medieval Dublin. Markets and fairs helped to make towns prosperous; especially since town corporations were allowed to tax the buyers and sellers of goods at such events.

Some coastal towns prospered as ports. Ireland's most important medieval towns, such as Dublin, Waterford and Youghal, Co. Cork were all ports that traded with Britain and beyond. Further afield, the Italian city of Venice traded with regions as far away as China and imported exotic goods, such as spices and jewels. Such foreign trade made Venice into a powerful and fabulously wealthy city.

★ **20** (a) In which order did the following arrive in Ireland? Start with the earliest:
the Vikings, the Celts, the Normans.

(i) _____ (ii) _____ (iii) _____

★ (b) Describe three important effects of the Norman invasion in Ireland.

(i) _____

(ii) _____

(iii) _____

★ (c) What does the Bayeaux Tapestry depict? _____

21 *The medieval speech bubble game – who said what?*

- The **speech bubble** statements labelled **1** to **9** on the next page would have been made by different types of people in the Middle Ages.
- The **grid** on the next page lists different types of medieval people.

The purpose of the game is to indicate **who said what**. Do this by ticking the correct box opposite each person listed in the grid. For example, speech bubble 1 (*'My home is a wattle-and-daub cottage in the village'*) would have been made by a peasant. So box 1 has been ticked after 'Peasant' in the grid. Now complete the exercise.

But **remember**:
- There is only one match for each bubble.
- Some people in the grid have no matching speech bubble.

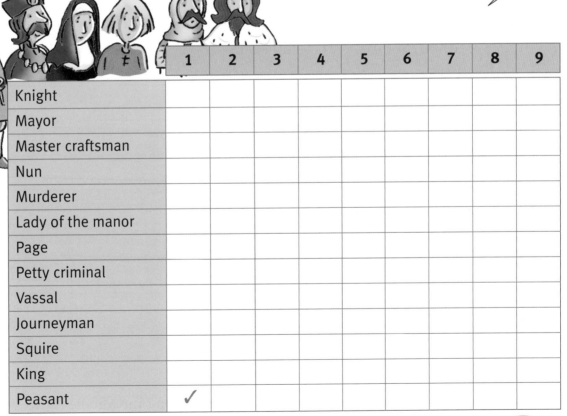

1. My home is a wattle-and-daub cottage in the village.

2. In the presence of many witnesses, I did pay homage to my Lord, swearing loyalty to him throughout my lifetime.

3. My dubbing will be on the next feast of the Holy Trinity. Thereafter I shall follow the rules of chivalry, swearing to live as a true knight.

4. My duties are to my home and to my Lord, to whom a great dowry was paid on our marriage.

5. My duties, as Leader of the Town Corporation, are many and varied.

8. The acceptance of my masterpiece by the guild now allows me to open my own workshop.

6. I know now full well what a shameful thing it is to be pilloried.

7. My trusty steed – the victim of an enemy lance – has perished in battle.

9. This country is mine – all of it. Everyone is either my vassal or my subject.

	1	2	3	4	5	6	7	8	9
Knight									
Mayor									
Master craftsman									
Nun									
Murderer									
Lady of the manor									
Page									
Petty criminal									
Vassal									
Journeyman									
Squire									
King									
Peasant	✓								

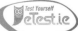

1 (a) The word *architecture* refers to

a religious order / the designing of buildings /

the copying of manuscripts

(Circle the correct alternative)

★ (b) The type of architecture shown in Source 1 is

Gothic ☐ Baroque ☐ Romanesque ☐

(Place a tick (✓) in the correct box)

2 In the spaces provided describe five contrasts (differences) between Romanesque and Gothic architecture.

Romanesque	Gothic
(i)	
(ii)	
(iii)	
(iv)	
(v)	

★**3** Give one reason why beautiful churches were built during the Middle Ages.

4 Write a brief but accurate description of each of the following terms that relate to the Church in the Middle Ages:

★ ● **Tithe** _____

★★ ● **Abbot** _____

★ ● **Tonsure** _____

★ ● **Refectory** _____

★ ● **Chapter House** _____

★ ● **Almoner** _____

★★ ● **Cloister** _____

★★ ● **Scriptorium** _____

★ ● **Dormitory** _____

★ ● **Sanctuary** _____

● **Friar** _____

★ 5 (a) Examine the drawing in Source 2, which shows the ground plan of a medieval monastery in Ireland. Select two parts of a monastery and briefly mention the purpose for which each part was used.

Part 1: _____

Purpose: _____

Part 2: _____

Purpose: _____

★ (b) Examine Source 3, which is a modern photograph of the monastery drawn in Source 2. Name two parts of the monastery that are shown in Source 2 that can still be seen today.

(i) _____ (ii) _____

★ (c) Name two advantages for a local community of having a monastery in its area.

(i) _____

(ii) _____

6 People in History

On the space below, write an account of a **monk in a medieval monastery**.

Tips:

- Try to write at least ten clear and relevant points. Each point should contain real historical facts.
- Lay out your account clearly and in paragraphs.
- This topic has been covered on page 63 of your textbook. Do **NOT** copy your account directly from the textbook. Learn page 63 first and then write your account without using the text.

Junior Certificate Examination marking scheme:

Eight clear and relevant points can be awarded 2 marks each.

(16 marks)

The overall layout and excellence of the piece can be awarded between 4 and 0 marks.

(4 marks)

Total: 20 marks

A Middle Ages Game

Two or more people can play this game.

To play you will need
- a dice
- a 'counter' for each player (a small piece of card with the player's initial on it would do).

Each person in turn throws the dice to move. Players must follow the instructions on the box on which their counters land.

The first person to complete the course **twice** wins.

You will be dubbed a **knight** shortly. Move on three spaces.

In town, someone empties a bucket of toilet waste on your head. Go back three spaces.

In which year did the **Normans** first invade Ireland? If you know, take an extra turn.

The crops fail. **Famine** threatens. Move back three spaces.

What is a **fief**? If you know, take an extra turn. If not, miss a turn.

What is a **barbican**? If you do not know, miss a turn.

The local **monastery** offers you an education. Take an extra turn.

You must pay to use the lord's **mill**. Go back three spaces.

Fire destroys your thatched house. Miss a turn.

The Black Death arrives in your village. Throw a 6 to continue.

Your castle is under **siege**. Throw a 5 or a 6 to continue.

Look forward to the annual **town fair**. Move on three spaces.

FINISH

START

You are a **serf** who has got sanctuary in a town. Take an extra turn.

You are put in the **pillory**. Throw a 4, a 5 or a 6 to continue.

36

★ **1** What was the Renaissance? _____

★★ **2** Give two reasons why the Renaissance began in Italy.

(i) _____

(ii) _____

★ **3** Explain the term *humanism*. _____

★★ **4** (a) Renaissance artists usually had *patrons*. What was a patron?

(b) Name one patron of artists during the Renaissance.

(c) Why were patrons so important during the Renaissance?

★ **5** Explain each of the following terms relating to the Renaissance:

● **Fresco** _____

● **Sfumato** _____

● **Perspective** _____

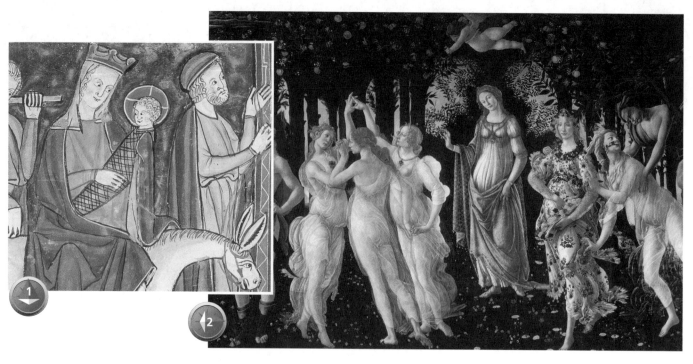

6 Study the paintings shown in Source 1 and in Source 2.

(a) Which of the Sources, 1 or 2, shows an example of a painting from the Renaissance? (Tick the correct box below)

Figure 1 ☐ Figure 2 ☐

(b) Give two reasons for your answer to question (a) above.

Reason 1: _____

Reason 2: _____

(c) Source 2 shows a painting the theme or subject matter of which is taken from classical civilisation. Why did many Renaissance artists often take their subject matter from the classical civilisations of Ancient Greece or Rome?

(d) Where are paintings such as those shown above usually kept?

★ 7 Write an account of four changes that took place in **painting** during the Renaissance.

(i) *Artists used perspective to make background objects seem small and far away. This gave depth and life to their paintings.*

(ii) _____

(iii) _____

(iv) _____

★ 8 (a) Name and briefly describe one work of art completed by Leonardo da Vinci.

- Name of work: _____

- Description: _____

★ (b) Name one Renaissance **painter** other than Leonardo da Vinci and name one of his works.

- Painter: _____ • Work: _____

★★ 9 (a) What is the sculpture shown in Source 3 called?

★★ (b) From what material is it made?

★★ (c) What is the theme of the sculpture?

(d) Who made the sculpture?

★★ (e) Name another Renaissance **sculptor** and name one of his works.

- Sculptor: _____ • Work: _____

10 Write an account of **architecture** during the Renaissance.

(i) *Fillippo Brunelleschi designed the dome of Florence Cathedral, which was the largest dome ever made.*

(ii) _____

(iii) _____

(iv) _____

> ### Marking Scheme
> * This question was for 10 marks in a Junior Certificate examination.
> * **Four clear, relevant points** are needed.
> * They must deal with the work of **more than one architect**.
>
> (One point has been completed already.)

11 Science and medicine in the Renaissance

Fill in the gaps in the passage below. Select some words from the Selection Box to do so.

A _____ priest named _____ Copernicus made an early breakthrough in Renaissance science. He believed that the _____ turned on its _____ and revolved around the _____. These views of Copernicus were published in a book called *On the Revolutions of the Heavenly _____*.

Galileo, who was an _____, supported Copernicus' theory in *The Dialogue*, a book that he published in _____. This landed him in trouble with a church _____ called the Inquisition. Galileo was forced to _____ his belief before he was allowed to return to his home.

Galileo was an extraordinary scientist. He studied _____ with the help of a powerful telescope that he made. He also invented a _____ and discovered that objects of different weights fell at the same speed.

In the field of medicine, the title 'father of modern anatomy' is given to _____ for his study of the human body. His book *On the _____ of the Human Body* was internationally famous. Another great medical scientist was William Harvey of _____.

Selection Box

Julius – sun – Dublin – earth – Hosts – England – Leonardo da Vinci – deny – axis – cuckoo clock – prove – Italian – Dr Tulp – the vernacular – Polish – astronomy – American – Roman – Nicolas – astrology – court – Andreas Vesalius – Spheres – Fabric – pendulum clock – Latin

12 In the boxes provided, match each letter in Column X with the number of its pair in Column Y. Two matches have been completed for you.

	Column X			Column Y		
A	Shakespeare	1	wrote *Don Quixote*	A		
B	Jan van Eyck	2	was a patron of the arts	B		
C	Galileo Galilei	3	was a northern Renaissance artist	C	6	
D	William Harvey	4	painted the *Birth of Venus*	D		
E	Johann Gütenberg	5	was a medical scientist	E		
F	Michelangelo	6	invented the pendulum clock	F	7	
G	Julius II	7	painted the *Last Judgement*	G		
H	Cervantes	8	invented movable-type printing	H		
I	Botticelli	9	wrote *Macbeth*	I		

★ **13** Give two reasons why there were so few female scientists or artists during the Renaissance.

(i) _____

(ii) _____

14 Indicate whether each of the following statements is true or false.
(Circle the *True* or *False* alternative in each case.)

(a) 'Lorenzo the Magnificent' was a great Patron of the Arts. *True / False*

(b) Albrecht Dürer was an artist of the Northern Resistance. *True / False*

(c) The Arnolfini Wedding Portrait was painted by Rembrandt. *True / False*

(d) William Shakespeare wrote more than 150 plays. *True / False*

★★ **15** **People in History**

Write on a printer during the Renaissance.

Marking Scheme

To answer this question:
- Make **at least eight** full, clear and relevant points.
- Lay out your answer in paragraphs.

In your answer, refer to several aspects of printing. You **may** refer to the following:
- The printer's name, home town, etc.
- How a printer was trained.
- How printing was done.
- Materials used in printing.
- Book or books being printed.
- The importance of printing.

16 Explain why the invention of **printing** is regarded as one
of the most important developments of the Renaissance.

> Frequently asked
> question.
> Make **four** good,
> clear points.

(i) _____

(ii) _____

(iii) _____

(iv) _____

17 Mention three **results** of the Renaissance.

(i) _____

(ii) _____

(iii) _____

Congratulations!
You have now completed the equivalent of your First Year History course. Celebrate by trying this **Giant First-Year Revision Word Puzzle.** The clues are given below.

Following each clue, you will find a **number in brackets**. This gives the **page of your Textbook** where the answer to each clue can be found.

Clues Across:

3. Letters that mean years before the Birth of Christ (6)
10. Wall painting (13)
11. A person who looks for artefacts in the ground (4)
13. Bronze Age necklace resembling a rope of gold (25)
14. Official papal documents in the Middle Ages (58)
16. 'The _ _ _ _ *Judgement*' by Michelangelo is painted in the Sistine Chapel (72)
18. Lough _ _ _ is the site of a Stone Age settlement in Co. Limerick (5)
23. An artist's way of making background objects seem far away (66)
26. The _ _ _ _ _ Fields in Co. Mayo are the site of a Stone Age farming settlement (24)
27. The evening meal in Ancient Rome (10)
30. Wealthy Florentine banking family that patronised Renaissance arts (68)
32. An organisation that controlled a craft in the Middle Ages (52)
33. 'Smokiness' – a Renaissance painting technique (66)
35. God of war in Ancient Rome (17)
37. 'The Fair _ _ _ _ _' – where medieval town fairs would be held (50)
38. Goddess of love in Ancient Rome (17)
39. Another Word for the *bailey* of a medieval castle (45)
40. Leader of a town corporation in the Middle Ages (50)
41. The Wicklow glen of St Kevin's monastery (34)

Clues Down:

1. Straw on the roof of a house (24)
2. Saint of Ardmore, Co. Waterford (34)
4. Famous monastery by the River Shannon (33)
5. Celtic stone fort (28)
6. Neolithic walls were of '_ _ _ _ _ _ and daub' (24)
7. A heap of small stones that covered the chambers of a court cairn (22)
8. A Wedge _ _ _ _ is a bit like a portal dolmen (26)
9. Portable funeral bed in Ancient Rome (17)
12. Famous Celtic brooch (28)
15. Floor or wall design made of coloured glass (13)
16. The Celtic god of war (29)
17. Leonardo da Vinci painted '*The last* _ _ _ _ _ _' (70)
19. Leonardo painted '*The Virgin of the* _ _ _ _ _' (70)
20. People who make cloth (13)
21. Dress worn by a woman in Ancient Rome (10)
22. Priest of the Ancient Celts (30)
24. Site of ancient monastery off Co. Kerry (33)
25. '*The Knight, Death and The* _ _ _ _ _' an engraving by Dürer (75)
28. Child of Roman legend who was suckled by a female wolf (7)
29. Used by Renaissance artists to bind paint (66)
31. Type of scarf or hood worn by a medieval peasant (48)
34. In Medieval times, a crime might cause a '_ _ _ and cry' (51)
35. Land and home of a medieval knight (47)
36. The shape of towers built in Ireland by early Christian monks (34)

★ **1** Give two reasons why rulers were prepared to sponsor voyages during the Age of Exploration.

(i) _____

(ii) _____

★ **2** Give two reasons why spices were so important in the fifteenth and sixteenth centuries.

(i) _____

(ii) _____

1

★ **3** (a) Name the type of ship in the picture in Source 1.

(b) Mention three reasons why this type of ship was more suited for longer voyages than were ships during the Middle Ages.

(i) _____

(ii) _____

(iii) _____

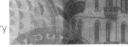

★ 4 Describe how each of the following developments in navigation made longer sea voyages possible during the fifteenth and sixteenth centuries.

● **Portolan chart** _____

● **Astrolabe** _____

● **Log and line** _____

● **Compass** _____

● **Quadrant** _____

★ 5 (a) Name the European country that discovered the sea route to India around the year 1500.

(b) What type of school did Prince Henry of Portugal establish at Sagres in 1420?

(c) Explain how the natives of the American continents came to be described as 'Indians'.

(d) Why are Spanish, Portuguese and English spoken widely in the Americas?

★ 6 Mention two dangers feared by sailors on voyages of discovery.

(i) _____

(ii) _____

★ 7 Study the map in Source 2 and answer the following questions:

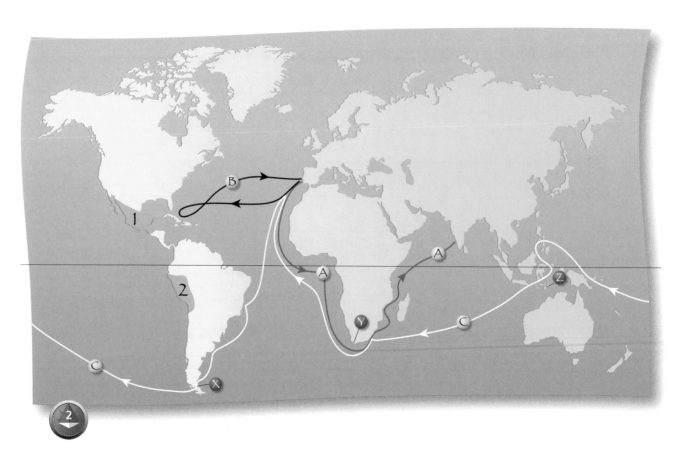

(a) (i) Name the leaders of each of the voyages of exploration marked **A**, **B** and **C**.

 A _____

 B _____

 C _____

 (ii) Identify the straits marked **X**. _____

 Identify the cape marked **Y**. _____

 Identify the islands marked **Z**. _____

 (iii) Name the civilisation in the area marked **1** that was conquered by Hernando Cortes.

 (iv) Name the civilisation marked **2** that was conquered by Francisco Pizarro.

(b) (i) Give one reason why the voyage of exploration marked **C** (on Source 2) took place some years after the voyage of exploration marked **B**.

(ii) Name the rulers of Spain who sponsored the voyage of exploration marked **B**.

(c) Explain why the voyage marked **B** took place.

This question was allocated 4 marks in a Junior Certificate examination. Give **two** significant, relevant points in your answer.

★ **8** Source 3 shows a copy of an ancient map that influenced Christopher Columbus. Examine Source 3 and answer the questions that follow.

Irlanda

Oceanus occidentalis

Cathay

Occides

Zaiton

Cippangu

Antilla

Canaria

Lisbona

Ories

Guinea

Caba Verde

Cathay = China
Cippangu = Japan
Occides = West
Ories = East

(a) Why in your opinion, is that part of the map showing the west coast of Africa so detailed?

(b) Mention two errors on the western side of the map.

(i) _____

(ii) _____

9 Examine the letter in Source 4 and answer the questions that follow.

4 *Letter from Amerigo Vespucci to his patron Lorenzo de Medici (1500)*

We were absent thirteen months on this voyage, exposing ourselves to terrible dangers, and discovering a very large part of Asia, and a great many islands, most of them inhabited. According to the calculations I have several times made with the compass, we sailed about five thousand leagues . . . We discovered immense regions, saw a vast number of people all naked, and speaking various languages. On the land we saw many wild animals, various kinds of birds, and an infinite number of trees, all aromatic.

We brought home pears in their growing state, and gold in the grain. We brought two stones, one of emerald, the other of amethyst, which was very hard, at least half a span long and three fingers thick. The sovereigns esteem them most highly, and have preserved them among their jewels . . . We brought many other stones which appeared beautiful to us, but of all these we did not bring a large quantity, as we were continually busy in our navigation, and did not stay long in any one place.

When we arrived in Cadiz, we sold many slaves. Finding two hundred remaining to us . . . thirty-two having died at sea . . . However, we are satisfied with having saved our lives, and thank God that during the whole voyage, out of fifty-seven Christian men, which was our number, only two had died, having been killed by the Indians.

Source: R. Hanbury-Tenison, The Oxford Book of Exploration, OUP 2005.

★ (a) How far did Vespucci and his crew sail? _____

★ (b) Mention two things that they discovered.

 (i) _____ (ii) _____

★ (c) Name two things that they brought back.

 (i) _____ (ii) _____

★ (d) Why, in your opinion, did so many slaves die on the voyage?

(e) What part of the world is called after Vespucci? Why? (Use your knowledge of history, not Source 4, to answer this question.)

Questions 10 and 11 were each allocated 12 marks in a Junior Certificate examination. Give at least six clear, relevant points in each answer.

10 ★ Write an account of the impact of exploration on native populations in the New World.

11 ★ Write an account of the benefits to European countries of voyages of exploration.

Play 'Double Match'

Column 2 gives the second names of a list of famous explorers.

- Use *Selection Box A* to help you write in Column 1 the correct first name for each explorer.
- Use *Selection Box B* to help you write in Column 3 the correct point of description for each explorer.

Column 1 First Name	Column 2 Second Name	Column 3 Point of description
Henry	'The navigator'	Had a school of navigation
	Diaz	
	Da gama	
	John	
	Columbus	
	Vespucci	
	Magellan	
	Cortes	
	Pizarro	

one match has been made for you

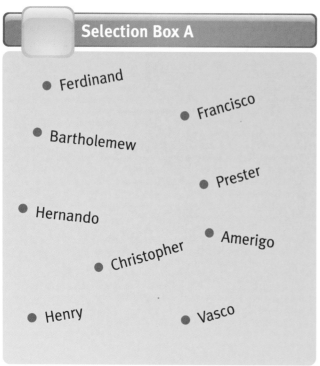

Selection Box A

- Ferdinand
- Francisco
- Bartholemew
- Prester
- Hernando
- Amerigo
- Christopher
- Henry
- Vasco

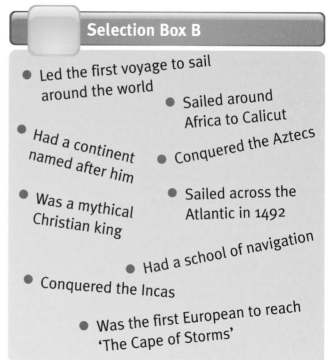

Selection Box B

- Led the first voyage to sail around the world
- Sailed around Africa to Calicut
- Had a continent named after him
- Conquered the Aztecs
- Was a mythical Christian king
- Sailed across the Atlantic in 1492
- Had a school of navigation
- Conquered the Incas
- Was the first European to reach 'The Cape of Storms'

1 Which of the following definitions best describes the Reformation? (*Tick ✓ the correct box*)

A. Attempts by people such as Ignatius Loyola to improve the Catholic Church from within ☐

B. A dispute that arose in Wittenburg, Germany, over the sale of indulgences ☐

C. Divisions in the Christian Church and the setting up of Protestant religions in the sixteenth century ☐

D. Changes in religion that took place in the fifteenth century ☐

2 On the spaces provided give the names of the church abuses 1–4 that were causes of the Reformation.

Abuse	Name of Abuse
1. Church positions were given to relatives of powerful churchmen	
2. Bishops did not live in their dioceses	
3. People used bribery to secure Church positions	
4. One bishop was in charge of several dioceses	

3 Mention two ways in which the Renaissance helped to cause the Reformation.

(i) _____

(ii) _____

★ **4** Mention one way in which the printing press helped the Reformation.

★ **5** This is a picture of Martin Luther burning a Papal Bull in Wittenberg, 10 December 1520.

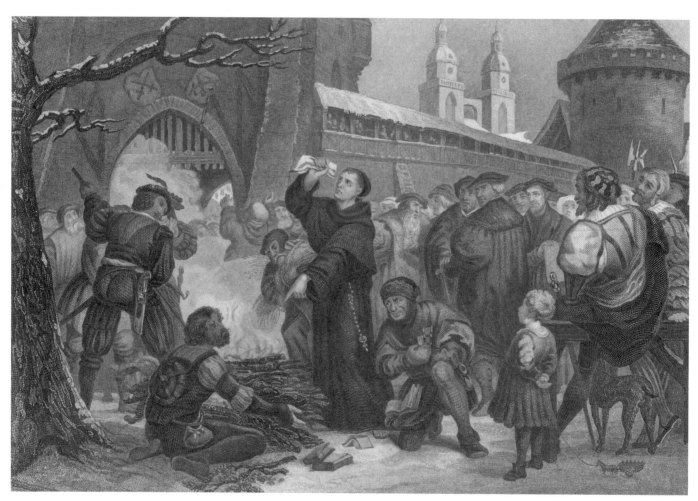

(a) What is a Papal Bull? _____

(b) Why is Luther burning the Papal Bull? _____

(c) What happened to Luther as a result of this action? _____

6 Statements **A–J** below refer to events in the life of **Martin Luther**. But the statements are not given in the order in which the events happened. On the grid provided, indicate the correct order of the statements. Two statements have already been put in order for you.

A Luther marries Catherine von Bora.

B The Diet of Worms is summoned.

C Frederick of Saxony has Luther detained (kidnapped).

D Luther is caught in a thunderstorm.

E Luther writes the 'ninety-five theses'.

F Luther joins the Augustinian Order.

G Luther translates the Bible at Wartburg Castle.

H Luther is excommunicated from the Church.

I The Edict of Worms is issued.

J John Tetzel arrives at Wittenberg.

The order in which events happened	Statements
1	D
2	F
3	
4	
5	
6	
7	
8	
9	
10	

7 The beliefs of Catholics, of Lutherans and of Calvinists varied with regard to (a) the number of sacraments that exist, and (b) who should control the Church on earth. In the boxes provided, indicate the varied beliefs on these two topics.

	Catholic beliefs	Lutheran beliefs	Calvinist beliefs
The number of sacraments			
Who should control the Church			

★ **8** What was the Counter Reformation?

★ **9** Mention two ways in which the Catholic Church responded to or was changed by the Protestant Reformation.

(i) _____

(ii) _____

10 Write an account of St Ignatius Loyola and of his role in the Counter Reformation.

This question carries 12 marks. Make at least **six** clear, relevant points.

★ **11** Write an account of the religious wars in Europe that followed the Reformation.

Make at least **five** clear, relevant points.

★ **12** How was Ireland affected by the Reformation?

Make at least **five** clear, relevant points.

13 **Bite-size word games**

Can you solve the three separate word puzzles below?

'Second' names of three famous religious reformers.

Church abuses that helped to cause the Reformation.

People all associated with the Reformation in England. They include a lady from Aragon, an 'eighth' king, an Anne and three men named Thomas.

1 Explain each of the following terms related to Irish history:

Write two sentences to explain each term.

★ • **The Pale** _____

★ • **Plantations** _____

★★ **2** Explain why the English began a policy of plantation in Ireland. Give three reasons.

(i) _____

(ii) _____

(iii) _____

★★ **3** Name two Irish plantations that you have studied. Name the monarch (king or queen) that ordered each of these plantations. Give the year of each plantation.

	Plantation	Monarch	Year
1			
2			

4 Examine Source 1. It is an illustration by an Englishman of a feast in Gaelic Ireland in the sixteenth century.

⭐ (a) State briefly what the people marked **A** and **B** are doing.

A: _____

B: _____

⭐ (b) What evidence does the picture offer to support the opinion that there are clergymen in the company?

⭐ (c) How are those seated at the table being entertained?

(d) Does this picture suggest that people in Gaelic Ireland are civilised or uncivilised? Explain your answer by referring to the picture.

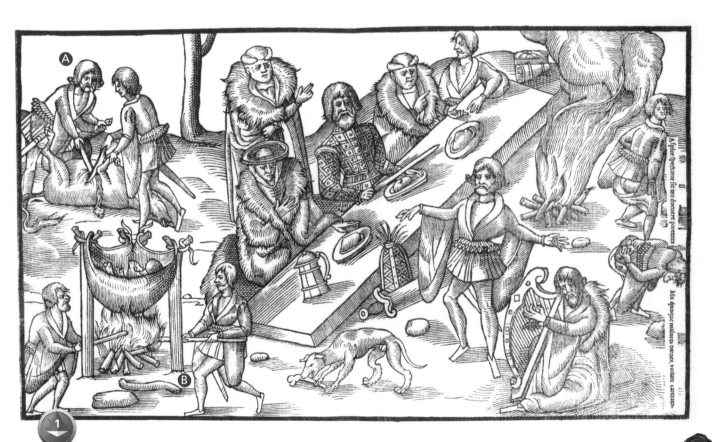

5 **Circle the correct alternatives** printed in purple in the passage below.

The Munster Plantation

In the mid-sixteenth century, much of Munster was controlled by the Fitzgeralds of Desmond / Ormond. But Queen Mary / Elizabeth upset the Fitzgeralds by appointing presidents / servitors to impose English law on Munster and by supporting undertakers / adventurers who made false claims on Fitzgerald lands.

The Fitzgeralds finally rebelled. They were helped by France / Spain, but were defeated. Their leader James / Thomas Fitzmaurice Fitzgerald was killed and the Desmond land was confiscated / purchased by the Crown.

The plantation that followed in 1586 / 1568 affected every Munster county except Clare / Waterford. Approximately half a million acres were first surveyed / serviced and then given to planters called undertakers / adventurers. They promised to pay the Crown an annual rent, to practise the Catholic / Protestant religion and to rent the land only to English / Irish people.

The Munster Plantation did not succeed in its objective of making Munster a permanently loyal province to the Crown. It was, however, a step in a long-term plan to extend / reduce England's control over Ireland.

★**6** Why did the planners of plantations in Ireland not wish the English or Scottish planters to have Irish tenants?

7 Describe three **consequences** of the Munster Plantation.

(i) _____

(ii) _____

(iii) _____

8 **The Plantation of Ulster**

In the boxes provided, match each letter in Column X with the number of its pair in Column Y.
One match has been completed for you.

	Column X
A	Undertaker
B	Servitor
C	Irish papist
D	Transplantable person
E	'The Irish Society'
F	The Anglican Church
G	The Diamond
H	'Red' Hugh

	Column Y
1	Central part of a Plantation town.
2	Undertook to accept an estate on certain conditions.
3	Person likely to be moved from his/her land to another area.
4	Received land owned previously by the Catholic Church.
5	Formally a soldier or official of the Crown.
6	London craft guilds.
7	Leader of the O'Donnell clan.
8	Catholic Irish person.

A	
B	
C	
D	3
E	
F	
G	
H	

★ **9** Write on the **consequences** of the Ulster Plantation under the following headings:

● **Political** _____

● **Culture and customs** _____

● **Religion** _____

★ 10 The Cromwellian Plantation

Study carefully the map of the Cromwellian land confiscation and answer the questions below.

Counties in which land was reserved for the adventurers and army

Counties in which land was reserved for the government

Counties (together with the eastern part of the barony of Tirawley, Co. Mayo) in which additional land was provided for the army

27 Percentage of land confiscated in each county

Counties assigned to the transplanted Catholics, who were not to be settled in the towns, on the islands or within a mile of the Shannon or the sea

Land confiscation in the Cromwellian Plantation

Source: T. W. Moody *et al.*, ed., *A New History of Ireland*, III, Clarendon Press 1976.

(a) How many counties were reserved for the adventurers and the army?

(b) Name the county in which the highest percentage of land was confiscated and the county in which the lowest percentage was confiscated.

Highest: _____ Lowest: _____

(c) It is noticeable from Source 2 that a relatively low percentage of land was confiscated in the west of Ulster. Why was this so?

(d) Why did adventurers and soldiers receive so much land under the terms of the Cromwellian Plantation?

(e) Catholics were not to be re-settled in the towns, on the islands or within a mile of the Shannon or the sea. Why do you think the English government made this order?

11 **Puzzle it out!**

On this word puzzle write the names of **five Munster Plantation towns** and **four towns of the Ulster Plantation.**

1 The map in Source 1 shows the thirteen British Colonies that became the first thirteen states of the USA. On the spaces in the grid name each of the following.

- the states or 'Colonies' labelled **A**, **B** and **C**
- the cities labelled **D**, **E** and **F**
- the territory or country labelled **G**
- the ocean labelled **H**

A	
B	
C	
D	
E	
F	
G	
H	

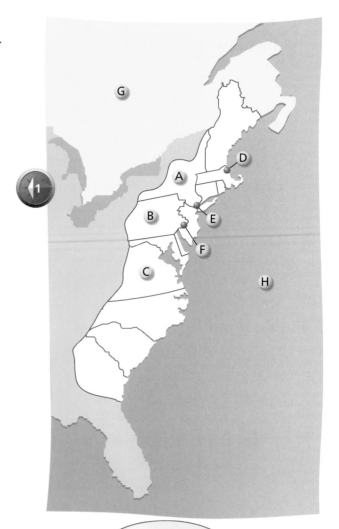

Write **three** points on **each** of these topics.

2 Explain how each of the following helped to cause the American War of Independence:

- **The Enlightenment:** _____

- **The Stamp Act:** _____

3 The five events listed below are **not** given in the order in which they happened.

- Enter the name of each event into the correct box attached to the **timeline** in Source 2.
- Use each box to write two things about the event in question.

The American Declaration of Independence – Yorktown – The Boston Massacre
– The Treaty of Versailles – Valley Forge

Event:

Event:

Event:

Event:

Event:

TIMELINE

1770

1771

1772

Boston Tea Party 1773

First Continental Congress 1774

Lexington, Concord, Bunker Hill 1775

1776

Saratoga 1777

French enter war 1778

1779

1780

1781

1782

1783

PERIOD of HOSTILITIES

★ **4** What were the effects of the French involvement in the American Revolution?

Try to write **four** significant, relevant points.

★ **5** Apart from French intervention, give two reasons why the Americans defeated the British during the American War of Independence.

(i) _____

(ii) _____

★ **6** Write an account of the role of **George Washington** in the American Revolution.

Try to write at least **seven** significant, releva points. Write **only** about Washington's involvement i the Revolution.

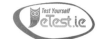

1 The statements **(a)** to **(i)** below describe terms used in Chapter 12 of your textbook. In the boxes provided name the term that is described by each statement. One term has been named for you.

(a) One of the three *Estates* in pre-revolutionary France, which consisted of the nobility.

> The Second Estate

(b) A tax paid to the Church that amounted to one tenth of the taxpayer's income.

(c) A period of new ideas that featured writers such as Rousseau and Voltaire.

(d) An assembly representing the three Estates that was called together in 1789 by Louis XVI.

(e) A document of 1789 that declared all men to be born free and equal.

(f) The town in which King Louis and his family were recognised and arrested as they tried to flee from France in 1791.

(g) The group of twelve people that came to power in France during the crisis of 1793.

(h) A period of bloodshed and fear, when Robespierre and his supporters executed 40,000 alleged enemies of the Revolution.

(i) A society inspired by the French Revolution and set up in Ireland by Wolfe Tone and others.

2 Source 1 is from a letter that gives an eyewitness account of **the execution of Louis XVI**. Study Source 1 and answer the questions that follow:

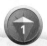

Paris, 23 January 1793, Wednesday morning.

My dearest Mother, I commend to you the spirit of the late lamented Louis XVI. He lost his life on Monday at half past ten in the morning, and to the very last he maintained the greatest possible courage.

He wished to speak to the people from the scaffold, but was interrupted by a drum-roll and was seized by the executioners, who were following their orders, and who pushed him straight under the fatal blade. He was able to speak only these words, in a very strong voice. 'I forgive my enemies; I trust that my death will be for the happiness of my people, but I grieve for France and I fear that she may suffer the anger of the Lord.'

The king took off his coat himself at the foot of the scaffold, and when someone sought to help him he said cheerfully: 'I do not need any help.' He also refused help to climb on to the scaffold and went up with a firm brisk step. The executioner wanted to cut his hair; he refused saying that it was not necessary. But on the scaffold the executioner tied his hands behind his back (this was when the King spoke to the people), and then cut his hair.

After his death his body and head were immediately taken to the parish cemetery and thrown into a pit fifteen feet deep, where they were consumed by quicklime. And so there remains nothing of this unhappy prince except the memory of his virtues and of his misfortunes.

Source: M. Bernard, cited in R. Cobb and C. Jones, *The French Revolution: Voices from a momentous epoch 1789–95*, Simon and Schuster 1998.

★(a) Mention one thing that happened when Louis tried to speak to the people.

★(b) Why did Louis 'grieve for France'?

★(c) Do you think Louis met his death bravely? Give one piece of evidence from the letter to support your answer.

★(d) What was the attitude of the writer to the execution of the King? Write down one example of evidence from the text that supports your answer.

(e) Explain briefly why Louis XVI was executed during the French Revolution.

(f) The guillotine was used to execute Louis. Name two other people who were executed by guillotine during the French Revolution.

(i) _____ (ii) _____

(g) In the case of one of the people you named in answer to question (f) above, explain why that person was executed.

3

Describe two major consequences of the French Revolution.

(i) _____

(ii) _____

4 **Multiple choice revision quiz**

(a) The French Revolution began in:

(i) 1789 ☐ (ii) 1791 ☐ (iii) 1798 ☐ (iv) 1879 ☐

(b) The Gabelle was:

(i) A land tax ☐ (ii) A salt tax ☐ (iii) A French Province ☐

(iv) Another name for Marie Antoinette ☐

(c) The following was **not** a famous writer of the Enlightenment:

(i) Voltaire ☐ (ii) Rousseau ☐ (iii) Montesquieu ☐

(iv) Lafayette ☐

(d) Jean Jacques Rousseau wrote a book entitled:

(i) *The Enlightenment* ☐ (ii) *The Social Contract* ☐

(iii) *People Power* ☐ (iv) *The Absolute Monarch* ☐

Tick the correct answer-box for each question. When you finish, find out how many questions you got right by checking your answers against those written upside-down at the bottom of the page.

(e) The main event of 6 October 1789 was:

(i) The Tennis Court Oath ☐ (ii) The Fall of the Bastille ☐

(iii) The March to Versailles ☐ (iv) The Flight to Varennes ☐

(f) The National Guard was set up to:

(i) Defend the King ☐ (ii) Defend the Estates General ☐

(iii) Defend the National Assembly ☐ (iv) Defend the nobles ☐

(g) Louis XVI was put on trial by:

(i) The National Assembly ☐ (ii) The National Guard ☐

(iii) The Committee of Public Safety ☐ (iv) The Convention ☐

(h) In 1793, the following countries were all at war against Revolutionary France:

(i) Holland, Spain and Prussia ☐ (ii) Austria, Russia and Britain ☐

(iii) Britain, Austria and the USA ☐ (iv) Russia, Poland and Austria ☐

(i) The 'Reign of Terror' was most supported by:

(i) Shopkeepers ☐ (ii) Priests and nobles ☐

(iii) Napoleon Bonaparte ☐ (iv) Sans culottes ☐

(j) 'The Incorruptible' was a name given to:

(i) Louis XVI ☐ (ii) Robespierre ☐

(iii) Rousseau ☐ (iv) Napoleon ☐

Correct answers

(a) i (b) ii (c) iv (d) ii (e) iii (f) iii (g) iv (h) i (i) iv (j) ii

★ **1** In the box provided, write the following events in their correct order. Start with the earliest.

- The French Revolution

- The 1798 Rebellion

- The American War of Independence

1	
2	
3	

★ **2** Connections between revolutions

In the spaces given below, describe how the American Revolution influenced the French Revolution and how the French Revolution influenced Ireland.

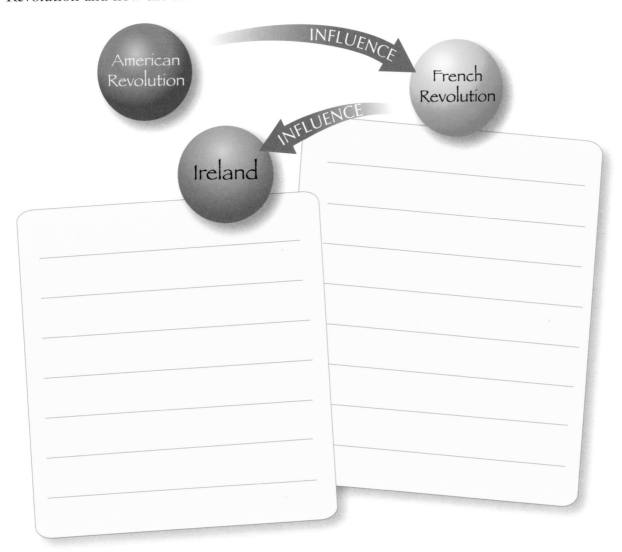

3 How did each of the following help to cause the 1798 rebellion?

- **Religious discrimination in Ireland** _____

- **Rural poverty in Ireland** _____

★★ **4** In the case of the 1798 rebellion, name:

(a) one rebel **leader**: _____

(b) one **aim** of that leader: _____

(c) one **event** associated with that leader: _____

5 Some main events of the 1798 rebellion in Wexford

Below is a list (in alphabetical order) of six places in Co. Wexford. An important event happened at each of those places during the 1798 rebellion.

- In the boxes labelled 1 to 6, describe these events in the order in which they happened. Write **at least two clear points** about each event.

☐ Boolavogue

☐ Enniscorthy

☐ New Ross

☐ Oulart Hill

☐ Vinegar Hill

☐ Wexford Town

6 On the grid provided, match each of the people in Column X with the correct item in Column Y. One match has been made for you.

	Column X
1	Wolfe Tone
2	Lord Edward Fitzgerald
3	Bagnel Harvey
4	Father John Murphy
5	Henry Joy McCracken
6	Henry Munroe
7	General Humbert
8	General Hoche
9	General Lake

	Column Y
A	'The Races of Castlebar'
B	Protestant leader of Wexford rebels
C	Terror tactics in Ulster and Leinster
D	Shot while being arrested
E	Revolt in Antrim town
F	Bantry Bay, December 1796
G	*An argument on behalf of the Catholics of Ireland*
H	Revolt in Ballinahinch
I	Boolavogue

1	G
2	
3	
4	
5	
6	
7	
8	
9	

★ **1** Describe two disadvantages of the open-field system of farming that existed in Britain before the Agricultural Revolution.

(i) _____

(ii) _____

★★ **2** Mention two factors that made the Agricultural Revolution possible.

(i) _____

(ii) _____

Fill in the grid below by selecting the appropriate words from Column X.

Important people of the Agricultural Revolution		
First name	Family name	Achievement
	Bakewell	
		Seed drill
Cyrus		
	Townshend	

Column X

- Charles
- mechanical reaper
- Tull
- Robert
- new crop rotation
- McCormack
- selective breeding
- Jethro

★**3** Describe the improvements made to farming by each of the people named in boxes **A**, **B** and **C**.

Commonly asked question

A

• **Tull** _____

★**4** (a) Explain the meaning of the term *enclosure* during the Agricultural Revolution.

B

• **Townshend** _____

(b) Read the old rhyme in Figure 2 below. To which consequence of enclosures is the rhyme referring?

'Tis bad enough in man or woman
To steal a goose from off the common,
But surely he's without excuse
Who steals the common from the goose.

2

(c) Describe two consequences of enclosures **not** referred to in your answer to question (b) above.

C

• **Bakewell** _____

(i) _____

(ii) _____

5 **People in history**

★ Imagine that you are a farmer in England during the Agricultural

★ Revolution. Write on the changes and on the effects of the changes
that took place during the Agricultural Revolution.

Hint
- Try to write **ten** significant, relevant points.
- Make sure you refer to **changes** that took place and to the **effects** of these changes.
- Use paragraphs **in your account**.

THE INDUSTRIAL REVOLUTION

1 Why did the Industrial Revolution begin in Britain? Give two explanations.

(i) _____

(ii) _____

Commonly asked questions

Write at least **three** significant, relevant points for each explanation.

2 (a) What type of work is being done by the woman in Source 1?

(b) State two ways in which working conditions shown in Source 1 were different from working conditions in factories during the Industrial Revolution.

(i) _____

(ii) _____

1

3 Fill in the first three columns of the grid below by selecting words from **Box X** and **Box Y**. Use the 'description of invention' column to mention what each invention was used for.

Inventors and their inventions			
First name	**Family name**	**Name of invention**	**Description of invention**
James			
	Arkwright		
		Rotary steam engine	
Abraham			
		Power loom	
	Kay		

Box X

- James
- Richard
- Cartwright
- Hargreaves
- Edmund
- John
- Darby
- Watt

Box Y

- coke
- spinning jenny
- water frame
- flying shuttle

4 The document in Source 3 contains extracts from interviews with children working in English factories during the Industrial Revolution. Read the documents and answer the questions that follow.

From an interview with Sarah Carpenter and James Patterson, factory workers, in the *Ashton Chronicle*, 23 June 1849

Sarah:

'They took me into the counting house and showed me a piece of paper with a red sealed horse on which they told me touch, and then to make a cross, which I did. This meant I had to stay at Cressbrook Mill till I was twenty-one.

Our common food was oatcake. It was thick and coarse. This oatcake was put into cans. Boiled milk and water was poured into it. This was our breakfast and supper. Our dinner was potato pie with boiled bacon in it, a bit here and a bit there, so thick with fat we could scarcely eat it, though we were hungry enough to eat anything. Tea we never saw, nor butter. We had cheese and brown bread once a year. We were only allowed three meals a day, though we got up at five in the morning and worked till nine at night.

We had eightpence a year given to us to spend: fourpence at the fair, and fourpence at the wakes. We had three miles to go to spend it. Very proud we were of it, for it seemed such a sight of money, we did not know how to spend it.'

James:

'I worked at Mr Braid's Mill at Duntruin. We worked as long as we could see. I could not say at what hour we stopped. There was no clock in the mill. There was nobody but the master and the master's son had a watch and so we did not know the time. The operatives were not permitted to have a watch. There was one man who had a watch but it was taken from him because he told the men the time.'

Source: www.Spartacus.co.uk

3

(a) Why did Sarah touch the red sealed horse and make a cross?

(b) What food were they given in the mill once a year? _____

(c) How much did she get to spend per year? _____

(d) Why do you think that the master did not want workers to know the time?

(e) From your study of this time, name two other problems which factory workers faced.

(i) _____

(ii) _____

5 Sources 4 to 9 below tell of working conditions in Britain's coal mines during the Industrial Revolution. Examine all of these sources and then answer questions (a) to (d) on the next page.

4 **A woman hurrier describes her work:**
'I have a belt around my waist and a chain passing between my legs and I go on my hands and feet. I have drawn [coal] till the skin was off me. The belt and chain are worse when we are in the family way [pregnant]. I have had three or four children born on the same day as I have been at work. Four of my eight children were stillborn.

The pit is very wet where I work and the water always comes over the tops of our clogs [wooden shoes]. I have seen it up to my thighs. My clothes are wet through all day long.'

5 **Sara Gooder, aged eight, describes her life as a trapper:**
'It does not tire me but I have to trap without a light and I'm scared. I never go to sleep. Sometimes I sing when I have a light, but never in the dark. I dare not sing then. I do not like being in the pit.'

7 **What mine owners said about trappers:**
The trapper is generally cheerful and contented. Like other children of his age, he is occupied with some childish amusement – cutting sticks, making models and drawing with chalk on his door.'

9 **An eleven-year-old girl describes her work as a hurrier:**
'[My father] takes me down at two in the morning and I come up at one or two in the afternoon. I have to carry my load up four ladders. My task each day is to fill four tubs. Each tub weighs more than a quarter of a ton. I fill four tubs in twenty journeys.

I have had the strap [been beaten] when I did not do my bidding.'

(a) Make a list of what **you** think were the five worst abuses in British mines that are revealed by sources 4 to 9. Write your list in **rank order**, beginning with the worst abuse.

(i) _____

(ii) _____

(iii) _____

(iv) _____

(v) _____

(b) Which of the sources 4 to 9 is the 'odd one out' because its evidence is contradictory or different to that of all the other sources?

(c) Do you think the source that you identified in your answer to question (b) is a reliable historical source? Explain your point of view.

(d) Briefly describe two reforms that were passed by the British Parliament in the nineteenth century to improve the lives of workers.

(i) _____

(ii) _____

6 Making iron and steel

- The *definitions* or *descriptions* of five terms are given in the Definitions Bank below.
- Use the *names* of these terms to fill correctly the boxes 1–5 under the heading 'How iron and steel were made'. One name has been written in for you.

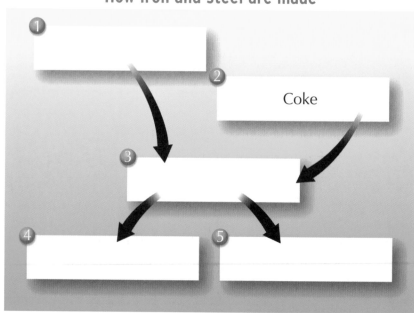

Definitions Bank

✓ A high quality product used to make cutlery.
✓ The raw material from which iron is made.
✓ This process takes place in a blast furnace.
✓ A source of power made from coal.
✓ A product that can be used to make nails.

How iron and steel are made

Coke

Commonly asked question

7 Describe two **effects** of the Industrial Revolution.

(i) _____

(ii) _____

1 Examine the three boxes on the right. Explain briefly but precisely how each of the things written in the boxes helped to cause the growth of British cities.

★ **2** Write an account of housing in industrial Britain in the nineteenth century.

- **Better agricultural yields** _____

- **Land enclosures** _____

- **The growth of factories** _____

3 Examine Source 1, which shows a plan of back-to-back terraced housing in London in 1850.

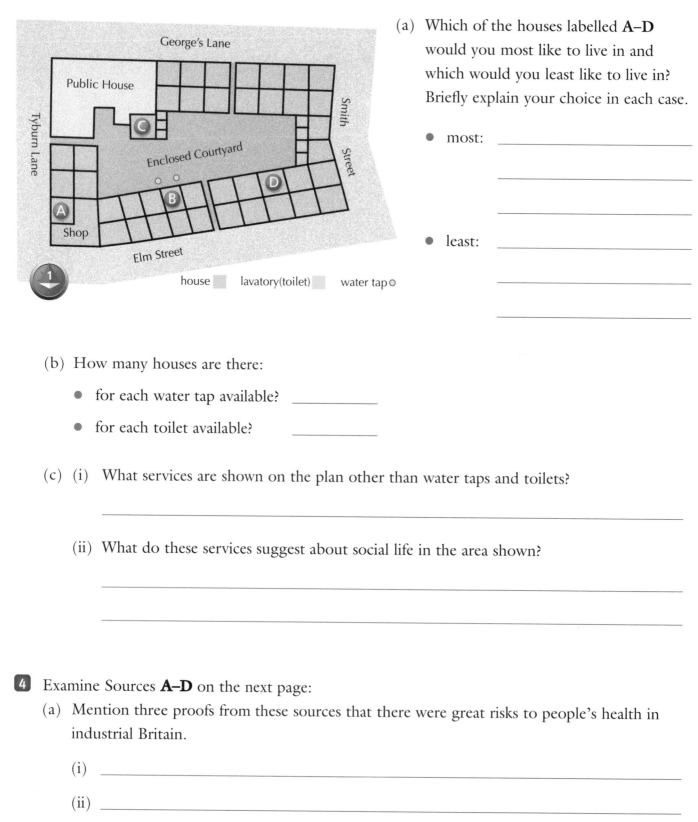

(a) Which of the houses labelled **A–D** would you most like to live in and which would you least like to live in? Briefly explain your choice in each case.

- most: _____

- least: _____

(b) How many houses are there:

- for each water tap available? _____

- for each toilet available? _____

(c) (i) What services are shown on the plan other than water taps and toilets?

(ii) What do these services suggest about social life in the area shown?

4 Examine Sources **A–D** on the next page:

(a) Mention three proofs from these sources that there were great risks to people's health in industrial Britain.

(i) _____

(ii) _____

(iii) _____

(b) Which particular piece of evidence from Sources **A–D** shocks you most? Why?

(c) Mention what the sources below suggest about each of the following:

- **Landlords** _____

- **The British government at that time** _____

A A description of the River Thames at a London slum:
'We saw drains and sewers emptying their filthy contents into it [the river]. We saw a whole row of privies [toilets with no doors], common to men and women, built over it. We heard bucket after bucket of filth splash into it. As we gazed in horror, we saw a child lower a tin can with a rope to fill a large bucket that stood beside her.'

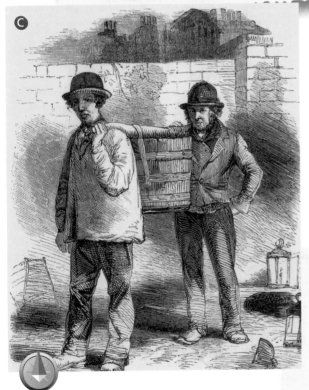

C

Night soilmen at their work

B A woman in Frying-Pan Alley, London describes her slum home:
'Look there,' said she, 'at the great hole; the landlord will not mend it. I have every night to sit and watch, or my husband sits to watch, because the hole is over a common sewer and the rats come up, sometimes twenty at a time. If we did not watch for them, they would eat the baby up.'

D A doctor describes a visit to a Liverpool slum:
I visited a poor woman in distress, the wife of a labouring man. She and her newly-born infant were lying in straw on a clay floor. There was no light or ventilation and the air was dreadful. I had to walk on bricks across the floor to reach her bedside, as the floor itself was flooded with stagnant water.

★ 5 Describe **health** and **leisure** in industrial Britain in the mid-nineteenth century.

> This question carried 14 marks in a Junior Certificate examination.
> ● Write **at least seven** clear and relevant points.
> ● Make sure you refer to health **and** leisure.

6 Complete the passage below by circling the correct *alternatives* that are given.

Some changes in industrial Britain

People's health began to improve when the Public Health Act of *1848 / 1948* set up Boards of *Health /Inspection* that organised street cleaning and the building of proper sewers. *Bart /James* Simpson's invention of chloroform and the invention of an antiseptic spray by Joseph *Pasteur / Lister* also helped people to live longer.

In the area of sports and recreation, the founding of the Football *Association /League* in the 1870s led to properly agreed rules for the game of soccer. The foundation of the *RSPCA /ISPCA* in 1824 led to the banning of *dog fighting /prize fighting*, although this blood sport continued to be practised illegally after that time.

One of the most important developments during the Industrial Revolution was the founding of trade unions such as the Grand National Consolidated Trades Union formed with the help of *Karl Marx /Robert Owen*.

1 Complete the passage below by selecting words from the Selection Box. Not all words in the Selection Box are relevant.

Road transport was improved by companies called turnpike _____. These companies maintained roads in exchange for fees called _____, which they charged to people at special barriers or gates called _____. Engineers named _____ MacAdam and Thomas _____ discovered new and better ways of building roads which had strong foundations and smooth, well-drained surfaces.

Heavy, bulky goods such as _____ and iron ore were well suited to transport by canal. The Earl of _____ hired James Brindley to build England's first canal. This canal was so successful that more than 6,000 kilometres of canal had been built in Britain by 1830.

The world's first rotary steam engine had been invented by James _____. This invention was pushed forward by Richard Trevithick, who in _____ developed a 'steam carriage' that could run on tracks. Rail transport began properly when a cargo train operated for the first time between Stockton and _____. In 1830, England's first passenger train ran between the cities of _____ and _____. This train was pulled by a famously fast engine called 'The _____', which had been developed by George _____ and which reached a speed of forty-six _____ an hour. From that time on, hard-working labourers called _____ laid down more and more railway lines across Britain.

Rail transport brought faster, cheaper and more comfortable travel to people all over Britain. An Act of Parliament in _____ required rail companies to provide cheap, 'one-penny' tickets to poor people who travelled in _____ class carriages. It was no wonder that rail transport became so popular that the mid-nineteenth century became known as 'The Railway Age'!

Selection Box

- Rocket
- coal
- navvies
- trusts
- 1844
- Manchester
- Watt
- 1944
- turnpikes
- Waterbridge
- third
- John
- Liverpool
- kilometres
- Telford
- Darlington
- bread
- tolls
- Birmingham
- 1804
- cover-charges
- Simpson
- Stephenson
- Bridgewater
- miles

2 Personalities of the revolutions – a word game

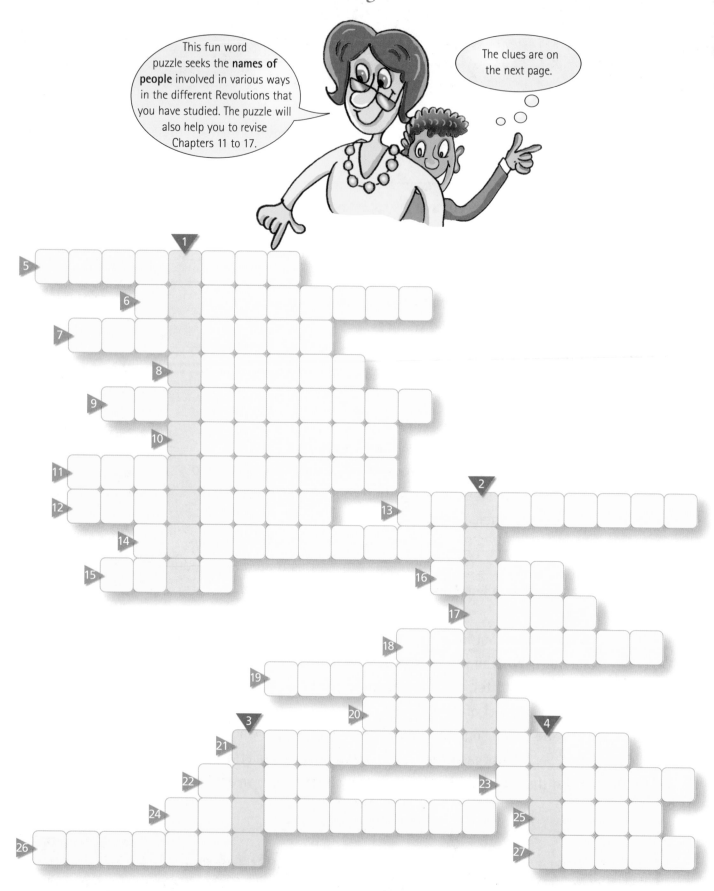

The number in brackets after each clue refers to the page in your Textbook where the answer to each clue can be found.

Clues Down:

1 This George was Commander in Chief of the American/Colonists army. (128)
2 Thomas invented a steam engine to pump water out of mines. (159)
3 Famous James invented the rotary steam engine. (159)
4 In 1701, Jethro invented the machine labelled **A** in the picture gallery. (154)

Clues Across:

5 Robert developed the selective breeding of farm animals. (153)
6 Marquis de _ _ _ _ _ _ _ _ _ was involved in both the American and French Revolutions. (134)
7 Jean Jacques' *The Social Contract* influenced the French Revolution. (134)
8 Bagnal led the men of Wexford in 1798. (146)
9 The Doctor who invented the machine labelled **B** in the picture gallery. (139)
10 Samuel was a leader of the Society of United Irishmen. (144)
11 James invented the spinning jenny. (157)
12 Writer of *The Enlightenment*. (143)
13 Napoleon _ _ _ _ _ _ _ _ _ is labelled **C** in the picture gallery. (140)
14 Maximilien 'The Incorruptible'. (140)
15 Theobald Wolfe _ _ _ _ was 'The father of Irish Republicanism'. (150)
16 Robert was a kindly factory owner who helped to form a trade union. (162)
17 Henry invented 'puddling and rolling'. (161)
18 Samuel invented a spinning machine called the 'mule'. (157)
19 John developed better roads. (172)
20 Robert led a rebellion in Ireland in 1803. (149)
21 Matilda was the sweetheart and wife of Theobald in 15 above. (144)
22 Karl called on 'workers of all countries to unite'. (163)
23 Henry led an uprising at Ballinahinch in 1798. (148)
24 Marie was the queen labelled **D** in the picture gallery. (135)
25 Used terror tactics to 'pacify' Ulster and Leinster before the 1798 rebellion. (145)
26 Landed at Killala with 1,000 men. (148)
27 The XVI King who lost his head in 1793. (139)

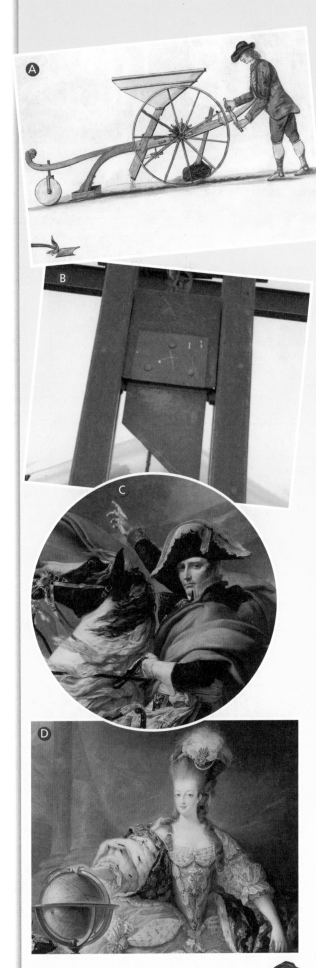

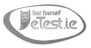

1 In the boxes provided, match each letter in Column X with the number of its pair in Column Y.

Column X	
A	Protestant Ascendancy
B	Middlemen
C	Dowries
D	Gavelling
E	Spalpeens
F	Stirabout
G	Workhouses

Column Y	
1	Type of porridge
2	Land agents
3	A system of land inheritance
4	Mostly descended from planters
5	Poorhouses
6	Wandering labourers
7	Valuables brought by women into marriage

A	
B	
C	
D	
E	
F	
G	

Tick the correct box in each case

2 Indicate whether each of the following statements is true or false.

(a) By 1845, most Irish people lived on holdings of one acre or less. *True* ☐ *False* ☐

(b) *Poteen* was illegal whiskey sold in specially licensed drinking houses called *shebeens*. *True* ☐ *False* ☐

(c) Father Mathew was a Dublin priest who began Ireland's temperance movement to discourage excessive drinking. *True* ☐ *False* ☐

(d) 'Gale days' were days when rents were paid to landlords or to middlemen. *True* ☐ *False* ☐

(e) Donnybrook Fair – held in what is now part of Dublin City – was once a notorious venue for faction fighting. *True* ☐ *False* ☐

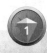

3 In the passage in Source 1 below, draw circles around the correct alternatives given.

'A journey through the Irish countryside at this time reveals an *urban/rural* community of widely varying circumstances, the great majority of whom suffer considerable poverty.

One can describe the landed gentry as being at the *top/bottom* of rural Ireland's prosperity pyramid. Secluded in their *humble/stately* homes, their lives appear to be jolly rounds of dining and of *hunting/hurling*. They have little real contact with those of more humble stations in life.

Members of the tenant-farmer class are mainly poor. The poorest tenants – those with *more/less* than 15 acres of land – live in houses of usually three rooms or *more/less*. Their diets of *bread/potatoes* and a porridge called *stirabout/gruel* seldom vary and many live in fear of *St Brigid's Day/Gale Day*, when rents must be paid or the threat of *eviction/imprisonment* must be faced. A minority of farmers – those with holdings of fifty acres or more – live in happier circumstances. They live in larger houses, some of which even boast *parlours/dining rooms* for the entertainment of special guests. They tend to follow the English custom of leaving their land to *all/one* of their sons and the marriages of their offspring are arranged with the help of *relatives/matchmakers*.

At the bottom of the prosperity pyramid are the wretched labourers. Toiling for a wage of no more than six *pence/shillings* a day, they struggle to survive on a diet of *stirabout/potatoes* in tiny thatched-roofed, *stone-floored/earthen-floored* hovels. These creatures live on the verge of destitution [absolute poverty] and in the shadow of the *workhouses/hiring fairs* that were set up for the alleviation of poverty in Ireland.'

Write **at least five** clear, relevant points.

4 Describe a typical labourer's house in mid-nineteenth century Ireland.

★ **1** Explain briefly but clearly each of the following terms relating to the Irish famine of the 1840s.

- **Lazybeds** _____

- **Blight** _____

- **Peel's brimstone** _____

- **Bloody flux** _____

- **Soup kitchens** _____

- **Coffin ships** _____

2 Indicate whether each of the following statements is true or false by ticking the _True_ or _False_ option.

(a) The famine relief schemes of Sir Robert Peel were more successful than those of Lord John Russell. *True* ☐ *False* ☐

(b) Irish emigration during the Great Famine was mainly to the USA. *True* ☐ *False* ☐

(c) Food was exported from Ireland during the Great Famine. *True* ☐ *False* ☐

3 Describe briefly three different relief schemes that were used to help victims of Ireland's Great Famine. In the case of each scheme, indicate why you think it was successful or unsuccessful.

(i) _____

Successful or unsuccessful: _____

(ii) _____

Successful or unsuccessful: _____

(iii) _____

Successful or unsuccessful: _____

4 Complete each of the following statements by filling the blank spaces. Take some words from the Selection Box to fill these spaces.

(a) A 'Lumper' was a variety of _____ popular before the Great Famine.

(b) Typhus and _____ fever spread quickly during the famine.

(c) Religious groups such as the _____ acted heroically to save the lives of Irish people during the famine.

(d) The importation of Indian corn or _____ saved many lives during the famine.

(e) Many Irish Famine emigrants later supported an Irish revolutionary movement called the _____.

Selection Box

- Quakers
- Land subdivision
- Mormons
- Corn
- Swamp
- Fianna
- Grain
- Fenians
- Friends
- Black
- Maize
- Potato
- Yellow

The extract in Source 1 is taken from a book called *Mo Scéal Féin*, by An tAthair Peadar Ó Laoghaire. It describes the plight of a poor family in the Macroom workhouse in Co. Cork during the Famine. *Examine the extract and answer the questions that follow.*

The father and the mother were enquiring . . . about Síle and Diarmaidín. Both children were not long dead when the parents became aware of it. All these poor people could speak Irish. The authorities were unable to speak the language or could only speak it badly. The poor people could learn of each other's welfare unknown to the authorities. As soon as the father and the mother heard of their children's deaths they were so stricken with grief and loneliness that they were unable to remain in the place. Both had been separated but they were able to contact each other. They decided to escape. The wife's name was Cáit, Pádraig escaped from the workhouse first. He stopped at the top of Bóthar na Sop to wait for Cáit. After some time he saw her coming but she was walking very slowly. She had fever.

They continued up towards Carraig an Staighre and arrived at the place where the mass grave was. They knew that the two children were buried in that grave with hundreds of other bodies. They stood by the graveside and cried bitterly . . . they left the graveside and headed northwest towards Doire Liath where their cabin was . . . they felt the pangs of hunger and Cáit was sick with fever so they had to walk slowly . . . they met neighbours. They were given something to drink and a little food but because they had come directly from the workhouse and because the woman had the dreaded fever people were afraid to invite them into their houses. Pádraig simply lifted his wife on his back and headed northwest towards the cabin . . . he reached the cabin which was cold and empty without fire or heat.

On the following day a certain neighbour came to the cabin and went in. He saw the two inside, dead and the woman's two feet were resting on Pádraig's chest as if he was trying to warm them. It seems that he realised because of the coldness of her feet that Cáit was about to die so he rested her feet on his chest to warm them.

Source: Norma Borthwick (ed.), *Mo Scéal Féin: An tAthair Peadar Ó Laoghaire*, National Library of Ireland 1915.

(a) What did Pádraig and Cáit (parents of Síle and Diarmaidín) do when they heard that their children had died?

(b) It seems that the members of the family were separated from each other. Mention two points of evidence from the passage to support this opinion.

(i) _____

(ii) _____

(c) What advantage was a knowledge of Irish to the poor people in the workhouse?

(d) 'People were afraid to invite them into their houses.' Why, according to the author, was this so?

(e) What did Pádraig do when he realised that Cáit was about to die?

(f) What was a workhouse? Why did people like Pádraig and Cáit go to workhouses during the famine?

★★ 6 (a) Why did the practice of subdividing holdings decline among Irish farmers after the Famine?

(b) Mention three results (other than the subdivision of farm holdings) of the Irish Famine of the 1840s.

(i) _____

(ii) _____

(iii) _____

CONTRASTING LIFESTYLES
FOR IRISH EMIGRANTS

★ ❶ Examine the extract in Source 1 and the drawing in Source 2, each of which refers to Irish navvies in England in the mid-nineteenth century. Answer the questions that follow.

'These Irish . . . insinuate* themselves everywhere. The worst dwellings are good enough for them; their clothing causes them little trouble, so long as it holds together by a single thread; shoes they know not; their food consists of potatoes and potatoes only; whatever they earn beyond these needs they spend upon drink. What does such a race want with high wages? The worst quarters of all the large towns are inhabited by Irishmen.'

* insinuate themselves = find their way.

(a) What was a navvy? _____

(b) In what kind of dwellings did the Irish workers live?

(c) Why does the writer of the extract believe that the Irish do not need high wages?

(d) Identify in Source 2 two working implements carried by an Irish worker.

(i) _____ (ii) _____

(e) Does the drawing of the Irish worker support or contradict the description given in the extract? Give a reason for your answer.

(f) Is there any evidence of *bias* in the extract? Briefly explain your answer.

★ **2** In the box below, describe contrasting lifestyles in rural Ireland and industrial England around 1850.

Write **at least six** clear points. Refer to both rural Ireland and industrial England.

97

1 Match each of the items in Column A with its corresponding item in Column B. Use the grid given. Two matches have been made for you.

	Column A
1	Herbert Asquith
2	Sir Edward Carson
3	John Redmond
4	James Connolly
5	Arthur Griffith
6	Douglas Hyde
7	The Irish Volunteers
8	Jim Larkin
9	The UVF

	Column B
A	Sinn Féin
B	Larne gun-running
C	The Irish Parliamentary Party
D	The Gaelic League
E	The Irish Citizen Army
F	Howth gun-running
G	British political leader
H	Unionist leader in Ireland
I	Founder of the ITGWU in Dublin

1	G
2	
3	
4	
5	
6	
7	F
8	
9	

2 Circle the correct alternatives in the passage below.

Irish Nationalism in the early Nineteenth Century

The Act of *Westminster / Union* had joined Ireland with England, Scotland and Wales in a single state officially called *Great Britain / the United Kingdom*. Under the Union, Ireland had no parliament of its own, but was ruled by the Parliament at *Kensington / Westminster* in London.

Irish nationalists did not like this situation. They thought that Ireland would be *more / less* prosperous if it ruled itself. They also believed that people with a different religion and culture to that in Britain *should/should not* be ruled directly from London.

Most nationalists supported the Irish *Parliamentary / Unionist* Party, which since 1900 had been led by *Charles / John* Redmond. They wanted *Home Rule / a Republic*, but were prepared to recognise the British monarch. Some nationalists wanted more. They agreed with the *IRB / UVF* that Ireland should be completely independent of Britain. They *were / were not* in favour of an armed uprising to achieve this aim.

Many nationalists were members of *cultural / political* organisations such as the Gaelic League and the GAA. The latter body was founded in 1884 in Thurles, Co. *Tipperary / Wexford*. Its leaders included Michael Cusack from Clare and its first president was Archbishop *Daly / Croke* of Cashel, after whom Ireland's greatest sports stadium is now named.

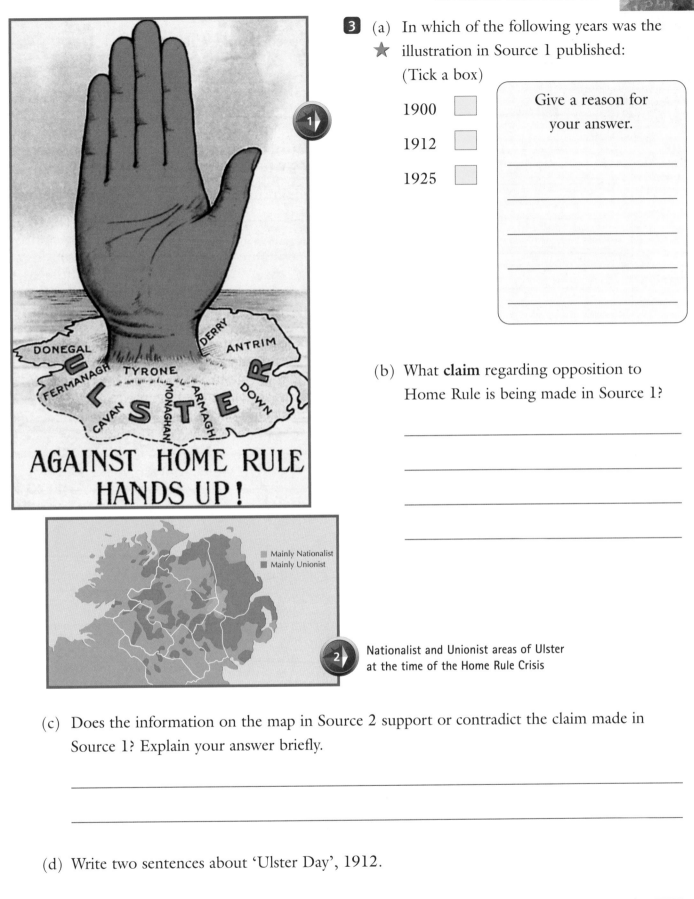

AGAINST HOME RULE
HANDS UP!

DONEGAL · DERRY · ANTRIM · FERMANAGH · TYRONE · CAVAN · MONAGHAN · ARMAGH · DOWN · ULSTER

3 (a) In which of the following years was the
illustration in Source 1 published:
(Tick a box)

1900 ☐

1912 ☐

1925 ☐

Give a reason for
your answer.

(b) What **claim** regarding opposition to
Home Rule is being made in Source 1?

Mainly Nationalist
Mainly Unionist

Nationalist and Unionist areas of Ulster
at the time of the Home Rule Crisis

(c) Does the information on the map in Source 2 support or contradict the claim made in
Source 1? Explain your answer briefly.

(d) Write two sentences about 'Ulster Day', 1912.

★ 4

In this box, explain why **Ulster Unionists opposed Home Rule**.

Write at least
six clear points.

5

In this box, write about the **Dublin Lockout**.

Write at least
six clear points.

★ 6

Life in the tenements was limited and confined. According to official classification, 22,701 people lived in 'third class' houses, which were termed as unfit for human habitation. One inspector reported, 'we have visited one house that we found to be occupied by 98 persons, another by 74 and a third by 73 . . . the entrance to all tenement houses is by a common door off either a street, lane or alley, and in most cases the door is never shut day or night. Generally the only water supply of the house is furnished by a single water tap, which is in the yard.'

Alcohol played a very large role in the lives of many. Workers who drank too much were left with little money to spend on the needs of their families. This problem was made worse by the custom in some areas, of paying workers their wages in pubs. It was not only the men who were inclined to see satisfaction in alcohol. Many grocery shops were situated within pubs, and this meant that the temptation for women to drink was always present. Alcohol offered an easy escape from the everyday troubles of life in the tenements.

Bad housing conditions, bad sanitation and poor diet gave rise to major health problems in tenement districts. There were several 'killer diseases' widespread throughout the city. The most common and most dreaded of these was TB or 'consumption' as it was commonly known. The poor living conditions were seen as directly responsible for about one third of the deaths registered in Dublin between 1902 and 1911. Some of these diseases – measles and whooping cough, for example – were highly contagious, spreading rapidly from one person to another. Overcrowding in the slums meant that these diseases were all the more dangerous and difficult to avoid.

Source: Curriculum Development Unit, *Dublin 1913 – A Divided City*, O'Brien Press 1978.

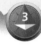

The extract in Source 3 above describes poor living conditions in Dublin tenements c.1913.

(a) How many people lived in houses that were unfit for human habitation?

(b) What was the largest number of tenants found in one house? _____

(c) What problems did alcohol cause in poor areas?

(d) Name two diseases mentioned that were highly contagious.

(i) _____ (ii) _____

7 **Hide and seek wordsearch**

The **Wordsearch** grid
contains the names of eight people who
were mentioned in Chapter 21 of your
Textbook. (These names may be written from
top to bottom, from bottom to top, from
left to right or from right to left).

(a) Find and circle each
of the names in the Wordsearch grid.
(b) Write the names of the right people
on the spaces below and mention one
historical fact about each.

The yellow boxes
will help you find
the names.

```
M T A N X L I O R E L M U V S T X I P A I T P I
T L V D Y Y R U Q O W M Y Z X P A Y T S E Z A O
H Y T N Z M T L U U Y T L T G O R T Y N T M T T
O T A O J N E D Y H S A L G U O D A Z I L I R O
M E X M T V L Z K K M L V Y S T S T U K Z T I L
A U T D D C T C U V Y M O T Z Y K U T R T V C M
S T L E T E V X L M I Z E V L T C Y V A T O K T
C H A R L E S S T E W A R T P A R N E L L T P R
L T T N L B C T E F G H I J K R T Y T M T E E R
A T T H T L M N O P Q R S T U Y B T B I I P A B
R L M O N O S R A C D R A W D E T V T J U M R I
K T Q J R Y M Z X Q M L Y Y E N S Y S S T N S R
E Y T I J A M E S C O N N O L L Y E L O V O E X
W T L N L T W Q Y I Z A X V N T N W W I Q S L O
```

Names	Historical facts
• _____	_____
• _____	_____
• _____	_____
• _____	_____
• _____	_____
• _____	_____
• _____	_____
• _____	_____

1 Write down the ten following events in their correct order, starting with the earliest event. Two events have been written in to start you off.

- The Rising begins on Easter Monday 21 April.
- The British suggest conscription for Ireland.
- James Connolly promises to support the rebellion.
- Rebel leaders are executed.
- The IRB sets up a Military Council to plan a rebellion.
- Dáil Éireann sits for the first time.
- The *Helga* bombards the GPO.
- The Rebels surrender.
- The General Election of 1918.
- The *Aud* is captured.

1 *The IRB sets up a Military Council to plan a rebellion.* _____

2 _____

3 *The **Aud** is captured.* _____

4 _____

5 _____

6 _____

7 _____

8 _____

9 _____

10 _____

2 Source 1 is a shortened version of the 1916 *Proclamation of an Irish Republic*. Read the document and answer the questions that follow:

POBLACHT NA H EIREANN.
THE PROVISIONAL GOVERNMENT
OF THE
IRISH REPUBLIC
TO THE PEOPLE OF IRELAND.

IRISHMEN AND IRISHWOMEN : In the name of God and of the dead generations from which she receives her old tradition of nationhood, Ireland, through us, summons her children to her flag and strikes for her freedom.

Having organised and trained her manhood through her secret revolutionary organisation, the Irish Republican Brotherhood, and through her open military organisations, the Irish Volunteers and the Irish Citizen Army, having patiently perfected her discipline, having resolutely waited for the right moment to reveal itself, she now seizes that moment, and, supported by her exiled children in America and by gallant allies in Europe, but relying in the first on her own strength, she strikes in full confidence of victory.

The Irish Republic is entitled to, and hereby claims, the allegiance of every Irishman and Irishwoman. The Republic guarantees religious and civil liberty, equal rights and equal opportunities to all its citizens, and declares its resolve to pursue the happiness and prosperity of the whole nation and of all its parts, cherishing all the children of the nation equally, and oblivious of the differences carefully fostered by an alien government, which have divided a minority from the majority in the past.

We place the cause of the Irish Republic under the protection of the Most High God, Whose blessing we invoke upon our arms, and we pray that no one who serves that cause will dishonour it by cowardice, inhumanity, or rapine. In this supreme hour the Irish nation must, by its valour and discipline and by the readiness of its children to sacrifice themselves for the common good, prove itself worthy of the august destiny to which it is called.

(a) From whom does Ireland receive her 'old tradition of nationhood'?

(b) Name one of the groups that 'organised and trained her manhood'.

(c) Give one piece of evidence to show that the Rising received support from outside of Ireland.

★ (d) What does the document in Source 1 accuse the 'alien government' of doing?

★ (e) Give two pieces of evidence from Source 1 to show how the leaders hoped that this document would encourage people to support the Rising.

(i) _____

(ii) _____

★ (f) The leaders of the Rising who signed this *Proclamation* were all executed by the British. State two consequences of the executions of the leaders of the Rising.

(i) _____

(ii) _____

(g) Fill in the surnames of the seven people who signed the *Proclamation* in the word puzzle provided here.

★ **1** Explain each of the following terms that relate to Ireland from 1919 to 1922.

- **Black and Tans** _____

- **Auxiliaries** _____

- **Flying Columns** _____

- **The Squad** _____

- **Bloody Sunday** _____

- **The Government of Ireland Act** _____

- **Dominion Status** _____

- **The Boundary Commission** _____

- **Irregular Forces** _____

2 The cartoon in Source 1 appeared in May 1922. It referred to a coming general election in Ireland. The Anglo–Irish Treaty was the main issue in the election.

Who or what is represented by the 'girl' who is being 'courted' by the two men?

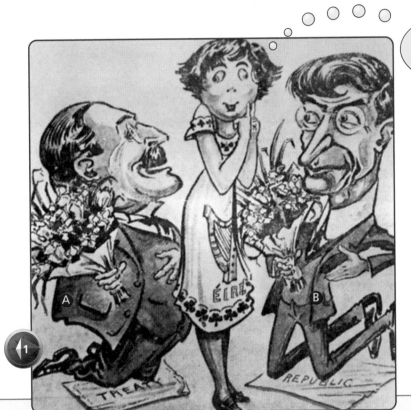

- Who is the man labelled **A**?

- Mention three arguments that he would make **in favour** of the Treaty.

 (i) _____

 (ii) _____

 (iii) _____

- Who is the man labelled **B**?

- Mention three arguments that he would make **against** the Treaty.

 (i) _____

 (ii) _____

 (iii) _____

Which of the two men won the general election of 1922? _____

3 The map in Source 2 shows the political division of Ireland following the Anglo–Irish Treaty.

Name the territories **A** and **B** into which Ireland was partitioned in 1922.

A _____

B _____

Name the cities labelled **X** and **Y**.

X _____

Y _____

Name the counties labelled **1–6**.

1 _____

2 _____

3 _____

4 _____

5 _____

6 _____

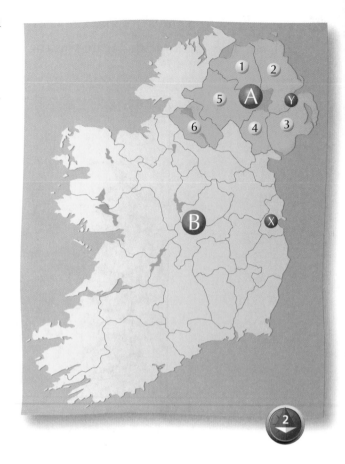

4 Match each of the items in Column A with its corresponding item in Column B. Use the grid given.

Column A		Column B			
1	Auxiliaries	A	Leader of anti-Treaty forces	1	
2	Sean Treacy	B	'Regulars'	2	
3	Michael Collins	C	Mostly former British Officers	3	
4	Lloyd George	D	British Prime Minister	4	
5	Berehaven	E	Soloheadbeg	5	
6	Free State Army	F	Béal na mBlath	6	
7	Éamon de Valera	G	'Treaty Port'	7	

Fill the gaps in the passage below by selecting words and phrases from the Selection Box.

A Cumann na nGaedheal government, led by _____ T. Cosgrave, ruled Ireland between 1923 and _____.

This government had several achievements. It set up the Irish _____ Company and the _____ Síochána. It set up a national _____ and succeeded in suppressing a dangerous Army _____, when officers threatened to disobey the government. It also encouraged the British government to pass the _____ of Westminster, which strengthened the independence of _____ such as Ireland.

Perhaps the greatest achievement of Cosgrave's government is illustrated in Source 1 below. This was the Shannon _____. It involved the building of a dam and power station at _____, which trebled the amount of _____ available to Irish people. A company named the _____ set up a 'national grid' that carried power from the Shannon to other parts of the country.

Despite its achievements, the Cumann na _____ government was soon surpassed in popularity by Éamon de Valera's _____ Fáil Party, which was founded in _____. De Valera and his TDs were forced by the Electoral _____ Act of 1927 to take the Oath of _____ to the British monarch before entering the Dáil. Nevertheless, their popularity grew as that of the government declined.

There were several reasons for the government's falling popularity. Unemployment and _____ were widespread in the country. The reduction of old-age _____ and Garda and _____ salaries added greatly to the government's unpopularity. So did the fact that Cumann na nGaedheal seemed to make no effort to transform the Irish Free State into the _____ that most people longed for.

Selection Box

- Fianna
- Scheme
- teachers'
- 1932
- emigration
- dominions
- ESB
- William
- Mutiny
- pensions
- nGaedheal
- Republic
- Garda
- hydroelectric
- Allegiance
- Sugar
- Ardnacrusha
- Amendment
- army
- electricity
- 1926
- Statute

1 Use the information in Source 1 to answer the questions that follow.

	1923	1927	1932	1933	1938
Cumann na nGaedheal	63*	47*	57	48	X
Sinn Féin	44	5	X	X	X
Fianna Fáil	X	44	72*	77*	77*
Farmers Party	15	11	3	X	X
Labour	14	22	7*	8	9
National League	X	8	14	X	X
Centre Party	X	X	X	11	X
Fine Gael	X	X	X	X	45
Independent (non-Party) TDs	17	16	14	9	7

X = Party did not exist or did not contest election
* = Party won power or shared power

Numbers of Dáil seats won by political parties in general elections between 1923 and 1938

(a) Only one political party contested all the elections shown. Name the Party.

(b) List the political parties that contested the 1932 general election.

(c) Which two parties shared power after the 1932 general election?

● _____ ● _____

(d) Cumann na nGaedheal and the Centre Party (together with the Blueshirts) joined to form a new party that contested the 1938 election for the first time.

● Name this new Party. _____

● How many seats did this Party win in 1938? _____

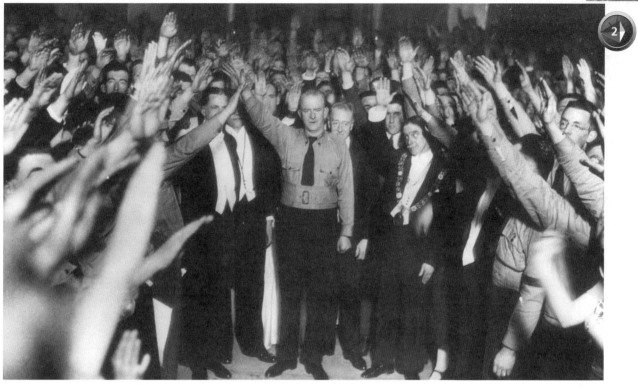

2 (a) To which organisation did the people shown in Source 2 belong? _____

★ (b) Name and write one other fact about the leader of that organisation.

Name: _____

Fact: _____

★ (c) In the box provided, write an account of the organisation.

Write **at least five** significant, relevant points.

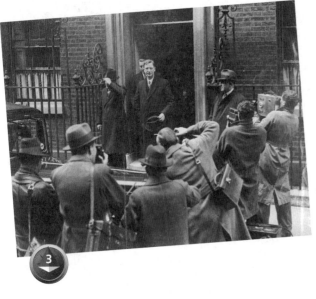

3 The picture in Source 3 shows An Taoiseach Mr de Valera at Number 10 Downing Street, where he signed the Anglo–Irish Agreement of 1938.

(a) Which British politician normally lives at Number 10 Downing Street?

(b) Why did the Irish government pay £10 million to the British government under the terms of the Anglo–Irish Agreement?

(c) Give two reasons why the Anglo–Irish Agreement of 1938 was important.

(i) _____

(ii) _____

(d) In this box write six clear points about **the Economic War** that ended with the Anglo–Irish Agreement.

- _____

- _____

- _____

- _____

- _____

- _____

1 The picture in Source 1 was printed at the end of the 'Emergency'. The woman represents Ireland and is saying 'Thank you' to the man.

(a) Who is the man?

(b) Why do you think Ireland is thanking the man?

(c) What is meant by the term 'the Emergency', as used above?

★ (d) What is meant by the term 'neutrality'?

★ (e) Give two reasons why Ireland remained neutral during World War II.

(i) _____

(ii) _____

(f) Mention one thing that Mr de Valera's government did to protect Irish neutrality during World War II.

2 Examine Source 2: it shows a cartoon from a humorous magazine called *The Dublin Opinion*. The lady opening the gas cooker exclaims 'Glory Be. It's the Glimmer man!'

'Glory Be. It's the Glimmer man!'

★ (a) What was a glimmer man?

★ (b) Give two reasons why it was necessary to have glimmer men in Ireland during the Emergency.

(i) _____

(ii) _____

★ (c) What attitude towards the glimmer man is revealed in the cartoon?

3 Mention two things that **Seán Lemass**, the Minister for Supplies, did to ensure that people's basic needs were met during the Emergency.

(i) _____

(ii) _____

4

Life in Éire during the Emergency

Shortages of food, clothing and fuel were the things I remember most about the Emergency. Seán Lemass was our Minister for _____. It was his job to make sure that the Free State had enough basic goods to survive and that scarce supplies were distributed fairly. Everyone was given a _____ book. You brought your book to the shops each week and used the coupons in it to buy small amounts of items such as a half-ounce of _____ and a half-pound of _____.

Fuel was very scarce. Gas, for example, was rationed. If the gas inspector – we called him the _____ man – caught you using too much gas, your supply could be cut off or you could be fined. Petrol for cars was given only to people such as priests and _____. The rest of us moved around on our bicycles or on foot. Even our Minister for Supplies, Mr _____, was known to cycle to work. We had no coal for our fires, so we had to use Irish turf instead. The trains were also operated on _____. They went so slowly that it often took people _____ hours to travel by train from Cork to Dublin.

Our economy suffered terribly during the Emergency. Farm production was down and a shortage of fuel caused many factories to close. Many unemployed people _____. Up to 50,000 joined the British forces to get work.

Our army was made much bigger to help us resist an invasion. We also had the _____, a part-time force of about a quarter of a million members. Our defence forces were fairly well trained but poorly armed. Some lads even had to train using fake wooden rifles!

My brother was a sailor in a new state-owned shipping company called _____. His job was dangerous. Although Éire was _____, there was always a danger of attack by a submarine. When he returned from sea, my brother sometimes brought back some bananas and _____. They were a great treat, because such fruit was not available here during the war.

One night in May 1941 German planes bombed part of the _____ area of Dublin. Everyone was shocked to hear that forty-one people were killed. But such incidents were very rare. Our government's policy of _____ saved us from the widespread destruction suffered by many other countries.

> Use words from the Selection Box to fill the gaps in the passage given here. Then learn the passage.

Selection Box

- doctors
- North Strand
- tea
- emigrated
- ration
- neutrality
- glimmer
- neutral
- turf
- Supplies
- Local Defence Force
- oranges
- sugar
- Irish Shipping
- Seán Lemass
- twelve

★ **1** Write an account of the First Inter-Party Government.

Write at least six significant, relevant points in answer to this **frequently asked question.**

- _____

- _____

- _____

- _____

- _____

- _____

2 The Mother and Child Scheme

(a) Which politician proposed the Mother and Child Scheme?

(b) Describe the purpose of the Scheme.

(c) Explain briefly why the Catholic Church opposed the Mother and Child Scheme.

3

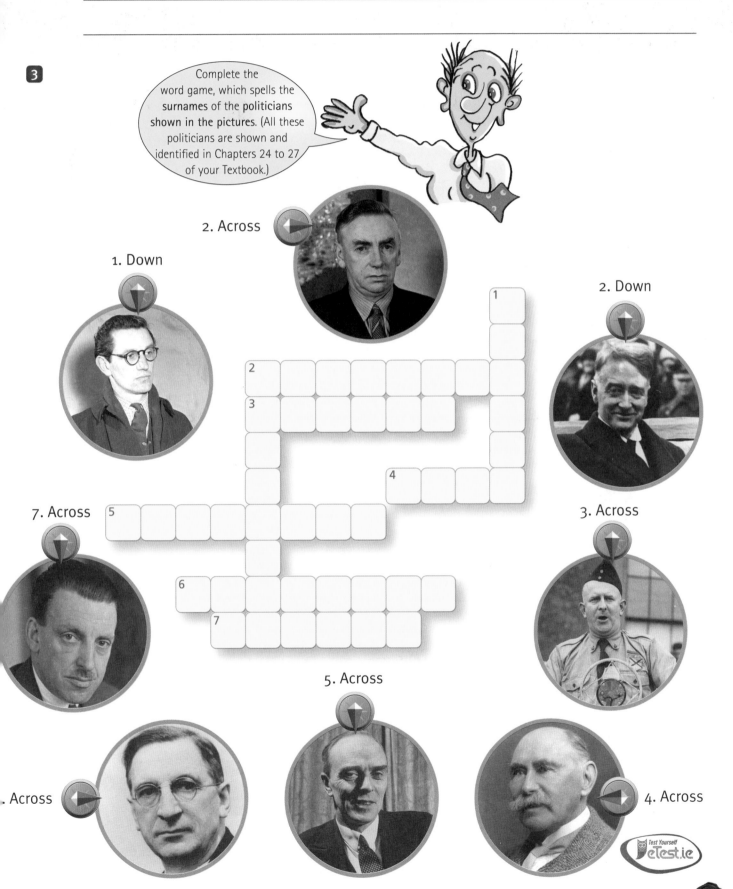

Complete the word game, which spells the **surnames of the politicians** shown in the pictures. (All these politicians are shown and identified in Chapters 24 to 27 of your Textbook.)

2. Across

1. Down

2. Down

7. Across

3. Across

5. Across

. Across

4. Across

1 Complete the missing words in the statements below.

The depressed fifties

1. The Republic of Ireland was ruled by Fianna _____ and by inter-party governments throughout the 1950s.

2. Irish governments placed _____ on foreign imports to protect Irish industry from foreign competition.

3. More than _____ thousand people emigrated from Ireland to Britain and America in the 1950s.

4. Minister for Health Dr _____ Browne proposed the _____ and Child Scheme in 1951.

5. Archbishop John _____ of Dublin played a big role in defeating Dr Browne's Scheme.

6. Ireland joined the _____ Nations in 19 _____.

7. In 1959, Éamon de Valera became _____ of Ireland and _____ _____ became Taoiseach.

The prosperous sixties

1. The government of Seán Lemass introduced the First Programme for _____ _____.

2. This Programme had been planned by a senior civil servant named T. K. _____. It gave grants and tax breaks to set up foreign _____ in Ireland.

3. The Programme resulted in more than _____ hundred new factories being built and caused unemployment to fall by _____ per cent.

4. Ireland's first television station was called _____. It opened in 19 _____.

5. Relations between the Republic and Northern Ireland improved when Seán Lemass met with _____, who was the Prime Minister of Northern Ireland.

6. In 1966, _____ replaced Seán Lemass as Taoiseach.

7. In 1967, Donough _____ announced the abolition of _____ in secondary schools.

2 Write down the following six events in the correct order in which they happened. Begin with the event that happened earliest.

> ● The Arms Crisis took place. ● Telefís Éireann opened.
> ● Ireland joined the EEC. ● Ireland joined the United Nations.
> ● Free secondary education was introduced. ● Seán Lemass became Taoiseach.

1 _____

2 _____

3 _____

4 _____

5 _____

6 _____

3 Source 1 shows population changes in Ireland's twenty-six counties between 1946 and 2002.

Year	Population
1946	2,955,107
1961	2,818,341
2002	3,917,203

1 Population of Ireland's twenty-six counties

(a) Calculate the decline in population between 1946 and 1961.

(b) Mention one historic reason for that decline.

(c) Calculate the increase in population between 1961 and 2002.

(d) Mention one historic reason for that increase.

★ **1** Write a sentence or two to explain each of the terms related to Northern Ireland that are listed below:

- **Partition** _____

- **Gerrymandering** _____

- **B-Specials** _____

- **Internment** _____

★ **2** In the box provided write an account of Northern Ireland Prime Minister **Terence O'Neill**.

Write **at least six** clear historical points.

3 The cartoon in Source 1 refers to traditional Orange Order marches through mainly Catholic areas in Northern Ireland.

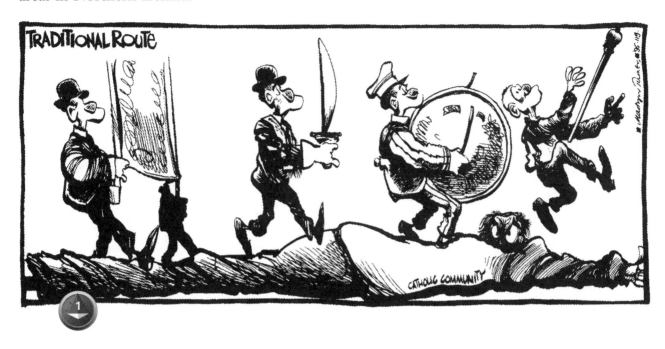

(a) What is the Orange Order? _____

(b) What message does the cartoon give about Orange Order marches?

(c) Do you think the cartoon has been fair to the Orange Order?
Briefly explain your point of view.

★ (d) Give two examples of discrimination that affected Catholics in Northern Ireland.

(i) _____

(ii) _____

★ **4** Write an account of **John Hume**.

Write at least eight clear historical points.

5 Match each of the people listed in Column X with the statement describing that person in Column Y. Use the grid provided to make these matches. One match has been made for you.

	Column X
1	James Craig
2	Bernadette Devlin
3	Brian Faulkner
4	William Whitelaw
5	Ian Paisley
6	Martin McGuinness

	Column Y
A	Introduced internment in 1971
B	Northern Ireland's first Secretary of State
C	Deputy First Minister of Northern Ireland in 2007
D	Civil Rights leader
E	Founded the Democratic Unionist Party
F	First Prime Minister of Northern Ireland

1	
2	
3	
4	
5	
6	C

6 Putting things in order

- Source 2 below is a box that lists nine important events in the history of Northern Ireland, but **not** in the order in which they happened.
- Source 3 is a timeline for Northern Ireland.

(a) On the spaces A–H in Source 3, write the events given in the box in the correct order in which they happened.

(b) Name the important world event that took place during the period coloured blue in the timeline.

✓ Internment begins

✓ The Welfare State is introduced

✓ The Good Friday Agreement

✓ The Government of Ireland Act is passed

✓ The Sunningdale Agreement

✓ British Army units are sent to the North

✓ The Hillsborough Agreement

✓ The Northern Ireland Civil Rights Association is set up

TIMELINE

A — 1920

1930

1940

B —

1950

1960

C

D — 1970

E

F — 1980

G —

1990

H — 2000

Northern Ireland Timeline

7 Source 4 shows a loyalist road block during the UWC strike in May 1974.

(a) What do the letters UWC stand for?

(b) Why was the strike historically important?

8 The grid below refers to three agreements that attempted to solve Northern Ireland's problems. In the boxes provided describe **what each agreement proposed** and **unionist objections** to the Sunningdale and Hillsborough Agreements.

Agreement	Proposals	Unionist Objections
Sunningdale Agreement 1973		
Hillsborough Agreement 1985		
Good Friday Agreement 1998		

chapter 30
SOCIAL CHANGE IN TWENTIETH-CENTURY IRELAND

★ **1** (a) Explain how each of the following **sources** might be useful to historians studying social change in Ireland in the twentieth century:

- Old photographs _____

- Census returns _____

- Interviews with elderly people _____

(b) Are the above sources all primary sources or all secondary sources? _____

★ **2** Write about the **impact** (effect) on Irish life of changes in communications since 1960.
Make **one** significant relevant point relating to each topic in the box.

- Better roads
- More cars
- Increased air travel
- Television
- Computers
- Mobile telephones

★ **3**

Describe three changes that took place in leisure activities in Ireland since 1900.

(i) _____

(ii) _____

(iii) _____

★ **4** Source 1 is an extract from an account by Jimmy Murray from Knockcroghery, Co. Roscommon. He was captain of his county when they won the All-Ireland football titles in 1943 and 1944. Examine Source 1 and answer the questions that follow.

'We were all very enthusiastic footballers, all right. Of course, that time there was nothing else to do much, anyway. I often say the money wasn't as plentiful as it is now. If I had a motor car (like my son has now), I wouldn't have been playing so much football in the evenings either. But that time was completely different. Nothing else to do except football and hurling. There are too many other counter-attractions these days.

We played every evening of the week during summertime. You got the feel of the blooming thing into your hand and you got so good at playing it on your toe or catching it and kicking it. Now, they don't play as much football at all, so I don't think they are as good at the basic skills as we were.

But then, the people were fitter of course, at that time. We cycled everywhere. Cycling, to me, is great exercise. I cycled to the dances, and I cycled to the football matches as well. Wherever you went within a range of fifteen miles, you cycled, anyway. You never thought about it. There was no one passing you out in a car, because there were no cars around, you know.

Then the farmers were working far harder. Now, every farmer has a tractor. He's sitting up on the tractor and that does all the work for him. That time, he had a shovel and a rake in his hands and he had a slane for cutting turf down the bogs. It was very hard manual labour indeed. And then he didn't need much training, you know. Our lads had no need of that at all.'

Source: M. Hickey, *Irish Days: Oral histories of the twentieth century*, Kyle Cathie 2001

(a) Give one possible reason suggested by the author why he and his friends were 'all very enthusiastic footballers'.

(b) How regularly did the author and his friends play football?

(c) Give two reasons why, according to the author, the footballers of the 1940s were fitter than those of today.

(i) _____

(ii) _____

(d) *There are too many other counter-attractions these days.*
From your study of social history, give two examples of possible 'counter-attractions' that the author may have had in mind.

(i) _____

(ii) _____

★ **5**

Describe the main changes that have taken place in **transport** in the twentieth century.

Marking Scheme
This question was awarded 12 marks in a Higher Level Junior Certificate examination. Make **six significant, relevant** points.

★ **6** The picture in Source 2 is of central Dublin in the early years of this century. Examine the picture and answer the questions that follow.

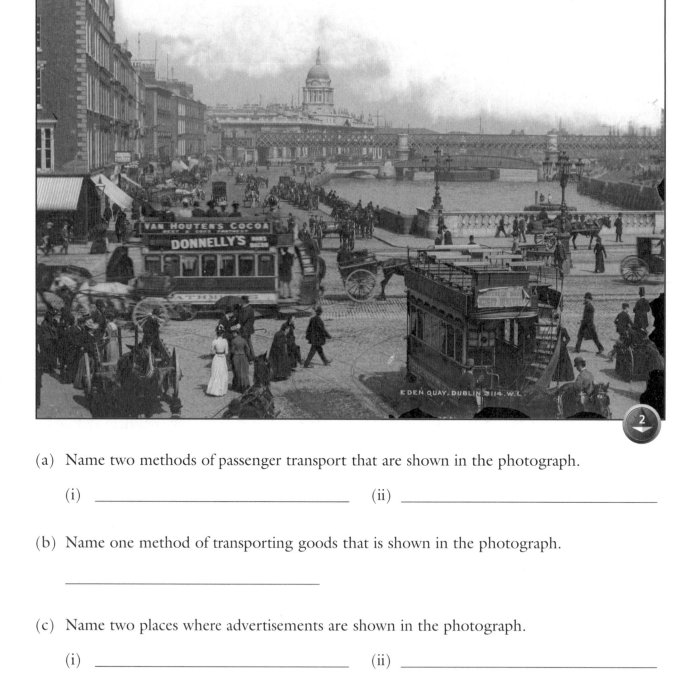

(a) Name two methods of passenger transport that are shown in the photograph.

(i) _____ (ii) _____

(b) Name one method of transporting goods that is shown in the photograph.

(c) Name two places where advertisements are shown in the photograph.

(i) _____ (ii) _____

(d) How does this street scene differ from a street scene in an Irish city or town today?

7 The pictures in sources 3–6 show scenes of farm work, rural housing, education and religious practice in early twentieth-century Ireland. In the spaces provided, describe changes that took place in the twentieth century in each of these aspects of rural living.

Farm work:

Rural housing:

Education:

Religious practice:

Revision word puzzle

(for Chapters 21 to 30)

Clues Down:

1 Where the War of Independence began in Co. Tipperary. (205)
2 This IRB Council planned the 1916 Rising. (199)

Clues Across:

3 Common name for Eoin O'Duffy's National Guard. (218)
4 This Order was set up to preserve British and Protestant control over Ireland. (191)
5 Where Civil Rights marchers were attacked in 1969. (237)
6 Minister for Supplies during the Emergency. (221)
7 Leader of IRA flying column in West Cork. (206)
8 This Sean was leader of Clann na Poblachta. (224)
9 He drew up the first Programme for Economic Expansion. (227)
10 John Hume and others set up this political party in 1979. (238)
11 This Co. Cork island was a 'Treaty Port'. (208)

12 Workers' leader and founder of the ITGWU. (193)
13 Founded in 1884 to promote Irish games. (192)
14 Éire was this during World War II. (221)
15 Leader of Home Rule Party in 1910. (194)
16 Severely rationed during the Emergency. (221)
17 1985 Agreement relating to Northern Ireland. (243)
18 The _____ crisis hit the Fianna Fáil Government in 1970. (229)
19 They checked gas usage during the Emergency. (222)
20 Became Taoiseach in 1966. (228)
21 Name given to anti-Treaty fighters in Ireland's Civil War. (209)

The **number** after each clue refers to the **Textbook page** where the answer can be found.

1 Complete the passage below by filling the blank spaces with some words selected from the Selection Box.

The League of Nations was set up in 1920 as a result of the Treaty of _____. Its main purpose was to be an international forum in which countries could work out their disputes in a _____ manner. Its policy of _____ security obliged League members to act together to prevent strong countries from attacking weaker ones.

But the League was weak from the beginning. The _____ refused to join, although its president, Mr Woodrow _____, was first to propose the setting up of the League. Entry was at first denied to _____ because of its role in World War I. The USSR (Russia) was excluded from the League until 1934 because it had a _____ government.

The weakness of the League was exposed when it did nothing to prevent _____ from invading the Chinese province of Manchuria or Italy from invading _____.

Selection Box

- Nazi - national - France - Paris - Wilson - Versailles - Great Britain
- Wellington - Abyssinia - peaceful - Japan - Egypt - Germany - warlike
- Communist - collective - United States

2 The cartoon in Source 1 shows doctors trying to revive a 'patient'.

(a) What body does the 'patient' represent?

(b) Outline two weaknesses that affected the body identified in part (a) above. (These should not include any of the problems or weaknesses referred to in Question 1 above.)

(i) _____

(ii) _____

This was from the British magazine *Punch* of 1938.

★ **1** Explain the meanings of each of the following terms from twentieth-century history:

- **Democracy** _____

- **Fascism** _____

- **Socialism** _____

★ **2** Indicate whether Fascism and Nazism are for or against each of the following:

	for	against
• Communism	☐	☐
• Democracy	☐	☐
• Nationalism	☐	☐
• Dictatorship	☐	☐

Tick the correct box in each case.

★ **3** Give two reasons why Fascism became popular in Europe in the 1920s and 1930s.

(i) _____

(ii) _____

★ **1** Fill in the missing words in the sentences (a) to (f) below:

(a) Mussolini's uniformed followers were known as _____.

(b) After World War I, many Italians were unhappy with the Treaty of _____.

(c) Many business people feared the spread of _____ and therefore supported Fascism.

(d) After the March on _____, Mussolini was appointed Prime Minister of Italy.

(e) The _____ Treaty, signed with the Pope in 1929, recognised the Vatican City as an independent state.

(f) In 1935, the Italians invaded _____.

2 Examine the events below. They are **not** given in the order in which they happened. Use the box to indicate the order in which these events happened. One entry has been made for you.

A The Rome–Berlin Axis is signed

B Abyssinia is invaded

C Mussolini takes power

D World War II begins

E The March on Rome

F The Fascio di Combattimento is founded

Order in which the events happened	
1st	F
2nd	
3rd	
4th	
5th	
6th	

3 The picture in Source 1 shows an event that happened in October 1922.

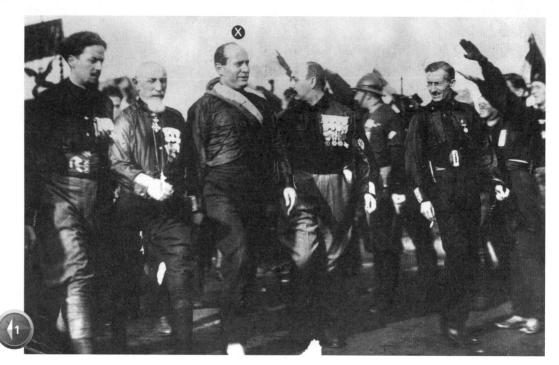

(a) What was the event? _____

(b) Name the man labelled **X** in the picture. _____

(c) Describe briefly the importance of the event. _____

★ 4 Write an account of Italy under Mussolini up to 1939. (12 marks)

Marking Scheme
- Write at least **five significant, relevant points** (clear points of history that answer the question asked). They will score 2 marks each.
- A further 2 marks are set aside as an 'overall mark'. Under this heading, 2, 1 or 0 marks are given, depending on the overall standard of your answer.

chapter 34 NAZI GERMANY

★ **1** Examine Source 1.

(a) Name the leaders labelled **X** and **Y**.

Leader X: _____

Leader Y: _____

(b) Name the country ruled by:

Leader X: _____

Leader Y: _____

(c) Describe two pieces of evidence in the photograph that support the statement that the two leaders were Fascists or Nazis.

(i) _____

(ii) _____

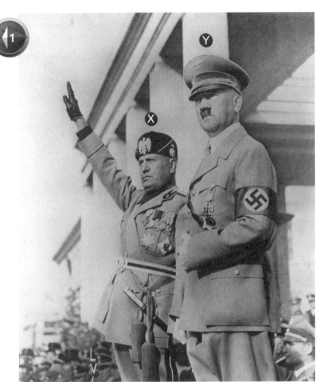

2 The cartoon in Source 2 refers to the Treaty of Versailles that followed World War I.

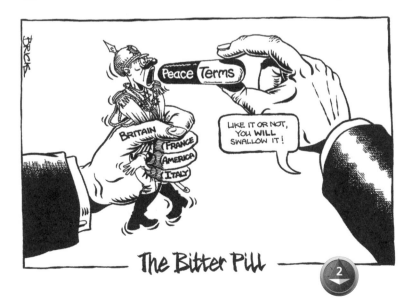

(a) What country is represented by the 'man' who is being forced to 'swallow' the peace terms of the treaty?

(b) Name four countries that are forcing the 'man' to swallow the peace terms.

(i) _____

(ii) _____

(iii) _____

(iv) _____

★
★ (c) Give two reasons why Germany was not satisfied with the Versailles settlement.

 (i) _____

 (ii) _____

★ (d) Give two reasons, excluding the Treaty of Versailles, why it was possible for Adolf Hitler to come to power in Germany.

 (i) _____

 (ii) _____

★ **3** Explain each of the following terms:
★

- **The Wall Street Crash** _____

- **The Brownshirts** _____

- **The Enabling Act** _____

- **The Night of the Long Knives** _____

- **The Nuremberg Laws** _____

- *Kristallnacht* _____

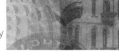

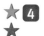 **4** Source 3 shows a Nazi propaganda poster from the 1930s. The writing on it says 'Youth serves the Führer' and 'All ten-year-olds in the Hitler Youth'.

(a) What was the Hitler Youth?

(b) How does the poster promote the idea of loyalty and obedience to Hitler?

(c) What is meant by the term 'propaganda'?

(d) Give two reasons why dictatorships such as Hitler's used propaganda.

(i) _____

(ii) _____

(e) Describe two ways that the German Nazi Party used propaganda to come to power.

(i) _____

(ii) _____

5 Source 4 is an eyewitness account of a visit to a school in Nazi Germany. Read the document and answer the questions that follow.

An eye-witness account of a school in Nazi Germany

When I arrived, the schoolyard was crowded with girls. They looked as serious as old women. Most of them were jumping, running, marching to the tunes of Nazi songs, to make their bodies strong for motherhood. Some were talking about Party duties, and the latest decrees of their Youth Leader, Frau Gertrud Scholtz-Klink.

A whistle shrilled and the girls gathered about an elevated platform. Different groups were assigned duties. Some were to go on hikes over the weekend, others were to attend anti-air-raid rehearsals. One of the troops, No. 10, was specially honoured. It had been selected by the district to represent the school at the annual parade on Hitler's birthday. The members were to be ready by six o'clock in the morning. The whole march would cover eleven miles. The girls were urged to carry their water flasks and a sandwich each.

For fifteen minutes the girls received minute instructions until each knew exactly what to do and when to do it. There was no whining, no complaining. Everybody seemed eager and happy to follow orders. The school bell called the girls. They did not break up their gathering very quickly. Their minds and hearts were set on ceremonies and stirring parades for the Führer. School, apparently, seemed monotonous in comparison.

Before I attended classes I spent an hour with the principal, a very friendly, neat lady of fifty. She explained that every class in school was built around a course called *Frauenshaffen*, activities of women. This general subject was divided into: *Handarbeit* (handwork), *Hauswirtschaft* (domestic science, cooking, house and garden work), and most important, the *Pflege* course (eugenics and hygiene; devoted to a study of the reproductive organs, both male and female; conception; birth; racial purity; infant care and family welfare).

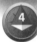

Source: G. Ziemer, *Education for Death: The making of the Nazi*, Octagon Books 1972.

(a) Quote two pieces of evidence to show that life in the school was orderly.

(i) _____

(ii) _____

(b) In what way was one group of girls 'specially honoured'?

(c) List three *Hauswirtschaft* subjects studied at school.

(i) _____ (ii) _____ (iii) _____

(d) Why would these students be made to study 'racial purity'?

6 Interpreting historical graphs

(a) The **line graph** in Source 5 shows changes in the numbers of unemployed people in Germany between 1928 and 1932. The **bar graphs** show the numbers of Nazi seats in the German parliament during the same period. State whether each of the following statements is true or false.

Write 'true' or 'false'

(i) The number of Nazi seats increased continuously during the period shown.

(ii) Unemployment figures and Nazi popularity were both relatively low in 1928.

(iii) As unemployment increased, so did the number of Nazi seats. _____

(iv) The Nazis' largest gain of seats was between the September 1930 and the July 1932 elections. _____

(v) The Nazis lost twenty-six seats between the July and November elections of 1932. _____

(vi) Germany had four elections within less than five years. _____

(b) Explain briefly why there was a connection between German unemployment figures and Nazi popularity during the time shown on the graphs.

Number of people out of work

6.1 million

6.0 million

230

196

5 million

3.4 million

107

1.7 million

Number of Nazi seats in parliament

12

Jan 1929

Jan 1930

Jan 1931

Jan 1932

Jan 1933

Election of May 1928

Election of Sept 1930

Election of July 1932

Election of Nov 1932

5

Word puzzle

This puzzle covers materials from Chapters 32 and 34.

The number given after each clue refers to the Textbook page where the answer can be found.

Clues Across:

2 Mussolini's Fascists murdered this brave Giacomo. (265)
4 The Night of the Long _____. (271)
6 Treaty that followed World War I. (261)
10 Mussolini's father was one. (263)
12 Hitler and Mussolini made the Pact of _____. (267)
13 Mussolini's dead body was displayed in this city. (267)
14 African country invaded by Mussolini. (266)
15 Emblem of the Fascist Party. (264)
17 This happening at Wall Street destroyed the German economy. (269)
18 In 1933, Hitler became this in Germany. (268)
20 Treaty between Mussolini and the Catholic Church. (266)

Clues Down:

1 German for 'The night of the Broken Glass'. (272)
2 _____ Kampf. (268)
3 Caused the cost of things to rise in Germany. (269)
5 Mussolini's first name. (263)
7 Hitler's 'living space'. (268)
8 Stormtroopers or Brownshirts belonged to this organisation. (268)
9 A concentration camp. (272)
11 Special military units fanatically loyal to Hitler. (271)
16 Mussolini liked to be called _____ Duce. (265)
19 A part of Germany occupied by French troops following the Treaty of Versailles. (269)

★ **1** Supply the missing words in the sentences (a) to (f) below:

(a) In 1936, German troops entered the _____.

(b) In the same year, Hitler and _____ formed an alliance known as the Rome–Berlin Axis.

(c) In March 1938, Germany took over Austria in an event known as _____.

(d) At the Munich Conference _____ was given to Germany.

(e) The rest of _____ was occupied by Germany in March 1939.

(f) The British prime minister, Neville Chamberlain, believed in a foreign policy known as

_____.

2 Use the grid provided to match each of the letters in Column X with the number of its pair in Column Y.

Column X		Column Y			
A	Lebensraum	1	Alliance between Germany and the USSR	A	
B	Pact of Steel	2	Giving in to someone so as to avoid conflict	B	
C	Nazi–Soviet Pact	3	Living space	C	
D	Luftwaffe	4	1 September 1939	D	
E	Conscription	5	Unity	E	
F	The Condor Legion	6	Young men are required to join the armed forces	F	
G	Appeasement	7	Took part in the Spanish Civil War	G	
H	Anschluss	8	Alliance between Germany and Italy	H	
I	Invasion of Poland	9	The German airforce	I	

3 **What Hitler did with the Treaty of Versailles**

Fill in the spaces on the table below.

Terms of the Treaty of Versailles	What Hitler did	Why he did it	The response from Britain and France
● Germany's **armed forces** were to be severely limited.			
● The **Rhineland** was to be a 'demilitarised zone' with no armed forces allowed.			
● Germany was forbidden to unite with **Austria**.			
● The **Sudetenland** was taken into the new state of Czechoslovkia.			

4 Source 1 shows part of the front page of a British newspaper of 8 October 1938. It reports on the return of the British delegation from an important conference held in Germany.

(a) Name and give the title or profession of the man labelled X in Source 1.

Name: _____ Title/Profession: _____

(b) Which conference created the hoped-for 'Peace for our time' referred to in Source 1?

(c) Name two leaders, other than the man labelled X in Source 1, that attended the conference.

(i) _____ (ii) _____

(d) What was decided at the conference referred to in Source 1?

(e) Was the 'Peace for our time' referred to in Source 1 a lasting peace?
Explain why or why not.

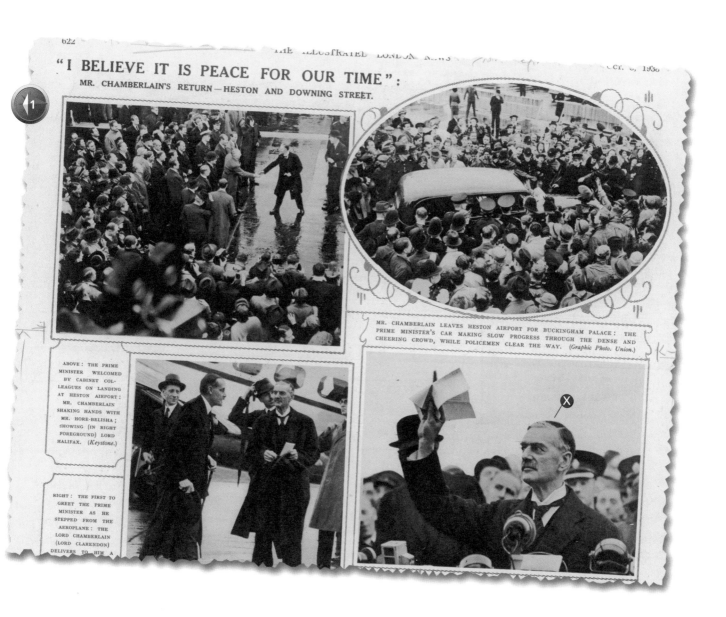

5 On the spaces provided on Source 2 name each of the countries or regions labelled **A–E** that were taken over by Hitler in the build-up to World War II. Indicate the order in which these places were taken over (which was taken first, second, etc.) by writing 1 to 5 after the name of each place.

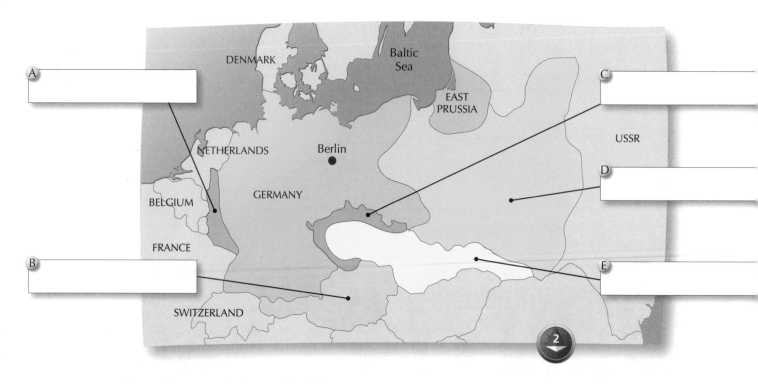

★ 6 Write an account of 'the expansion of Nazi Germany and the road to war in Europe 1933–39'.

Marking Scheme hints
- This question was awarded 14 marks in a Junior Certificate examination.
- Write **at least seven significant, relevant points** in your answer.

36 WORLD WAR II

1 Explain briefly the meaning of each of the following terms that relate to World War II.

★ **Blitzkrieg** _____

★ **The Phoney War** _____

★ **Vichy France** _____

★ **Luftwaffe** _____

★ **The Blitz** _____

★ **Neutrality** _____

★ **Lebensraum** _____

★ **Scorched earth** _____

2 Examine the picture in Source 1.

⭐(a) What is the correct name of the symbol that is being destroyed?

(b) Which country does each of the 'hands' labelled **A–D** represent?

Ⓐ _____

Ⓑ _____

Ⓒ _____

Ⓓ _____

⭐ (c) Name two countries that fought on the side of Nazi Germany during World War II.

(i) _____ (ii) _____

⭐ (d) Excluding Ireland, name two countries that remained **neutral** during World War II.

(i) _____ (ii) _____

⭐**3**

Write an account of **German successes** in the war, from the invasion of Poland to the invasion of the Soviet Union.

Make at least five significant, relevant points.

4

★ (a) Why did Neville Chamberlain, the British prime minister, resign in May 1940?

★ (b) Why was there a resistance movement in France, 1939–45?

★ (c) Why did women make up most of the workforce at Britain's Rolls Royce car factory between 1939 and 1945?

5 **Know your 'operations'**

Complete each of the sentences below by choosing the name of the 'operation' from the Selection Box. Identify the order in which these four 'operations' happened by writing 1 opposite the earliest, 2 after the next earliest and so on.

The order in which these
Operations happened

- Germany's invasion of the Soviet Union was called Operation _____ ☐

- The British troop evacuation from Dunkirk was called Operation _____ ☐

- The Allied invasion of France was code-named Operation _____ ☐

- Germany's plan to invade Britain was code-named Operation _____ ☐

Selection Box

● Sealion ● Overlord ● Barbarossa ● Dynamo

6 London during the Blitz

Source 2 is an extract from an interview with Myrtle Solomon, a Londoner who survived the 1940 Blitz in London. Read the extract and answer the questions that follow.

We had a very big basement and my mother said, 'We'll just open it up.' So people came in every night, for, I believe years – long after the Blitz. There were people we didn't know – because you know how it is in London – how little you know your neighbours. But there were many families there, including two Italians and Austrians. Their husbands got taken away to internment camps in Britain, which was a very grim experience for the wives, who came every night to the shelters. I remember trying desperately to help get their husbands out. One was an Italian doctor, whose wife was nearly going mad without him.

It was not required at that stage, but several of us in the road went voluntarily to take a short course in what to do when incendiaries dropped. We were equipped with stirrup pumps, water and sand – nearly all of which seemed to be totally useless. Because the stirrup pump didn't work, I remember kicking incendiary bombs off the roof with my feet, or the end of a broom, just to get them into the garden away from the roof of our house.

I remember throwing sand on a bomb for ages. I kept doing exactly what I'd been told to do and throwing this sand on, and it just flared up again. The planes were still overhead, and you thought they could see you – and thought if they saw fire going, they would drop another bomb on you. So you were absolutely petrified.

In the morning, you felt good to be alive – but with this awful sense of guilt that other people weren't – and shouldn't it really have been you?

Source: Max Arthur, *Forgotten Voices of The Second World War*, Random House 2004.

★ (a) Why do you think that people kept coming to the basement every night, long after the Blitz was over?

★ (b) Give two examples from the extract of acts of bravery or kindness on the part of Myrtle's family.

(i) _____

(ii) _____

★ (c) Name two methods that were used to deal with the danger of incendiary bombs.

(i) _____

(ii) _____

★ (d) Give two reasons why the Luftwaffe was bombing London and other British cities.

(i) _____

(ii) _____

★ (e) Figure 3 shows a British 'ration book'. Ration books were needed to buy even very small amounts of items such as tea and sugar.

Why do you think food was rationed during wartime?

3

ON HIS MAJESTY'S SERVICE

OFFICIAL PAID

N. **Your Ration Book**

Issued to safeguard your food supply

HOLDER'S NAME AND REGISTERED ADDRESS

COMPARE WITH YOUR IDENTITY CARD AND REPORT ANY DIFFERENCE TO YOUR FOOD OFFICE

DO NOT ALTER

Surname TAPPENDEN

Other Names J. Margaret

Address 58. Beemsfield Rd

SE 3.

NAT. REG. NO. AHAV 369 2

Date of Issue -7 JUL 1941 Serial Number of Book

If found, please return to

GREENWICH PS 728578

FOOD OFFICE. R.B.1 [General] 4

★ **7** Describe **life in London during the Blitz**, **without** using any of the information given in Sources 2 or 3.

Make at least six significant, relevant points.

8 The picture in Source 4 shows the German invasion of the Soviet Union during World War II.

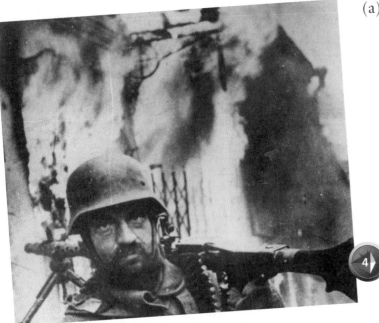

4

(a) Why did Hitler order the invasion of the Soviet Union? Give two reasons.

(i) _____

(ii) _____

(b) Describe the Battle of Stalingrad.

Make at least six significant, relevant points.

(c) Mention two reasons for Germany's defeat in the Soviet Union.

(i) _____

(ii) _____

★ (d) Historians believe that Hitler made a serious mistake when he invaded Russia in 1941. What is your opinion? Give one reason for your answer.

9 Conflicts in the Pacific and Atlantic

Complete the passage below by filling the gaps and circling the correct alternatives.

War in the Pacific began on 6 December **1939/1941**, when Japan attacked the **British/American** naval base at Pearl _____ in Hawaii. When the United States entered the war on the **Allied/Axis** side, it contributed huge wealth and a massive army to that side. The Americans won a decisive victory over Japan at the Battle of **Midway Island/Halfway Island**. They then advanced towards Japan itself. The Japanese defended fiercely. Suicide pilots called _____ pilots crashed aircraft packed with explosives into US ships. Eventually America's President Harry _____ decided to employ terrible, newly invented weapons to force Japan to surrender. In August 1945, atomic bombs were used to destroy the Japanese cities of Hiroshima and _____.

The so-called Battle of the Atlantic was really a prolonged struggle between Allied ships and German **destroyers/submarines** called U-boats. The Allies used large groups of ships called _____ and underwater explosives called depth _____ against the U-boats. In March **1944/1945**, the Germans finally called off their U-boat campaign.

5

10 Use the grid provided to match each of the letters in Column X with the numbers in Column Y.

Column X	
A	Roosevelt
B	Stalin
C	Churchill
D	Rommel
E	Montgomery
F	Zhukov

Column Y	
1	German general
2	Soviet leader
3	British general
4	British prime minister
5	Soviet general
6	US president

A	
B	
C	
D	
E	
F	

11 Examine the World War II propaganda poster shown in Source 6.

(a) Which of the following countries was
most likely to have produced this poster?
(Tick the appropriate box)

Germany ☐

USSR ☐

Britain ☐

Japan ☐

(b) To which of the following events does the
poster refer:

The Battle of Britain ☐

Operation Barbarossa ☐

Operation Overlord ☐

The Fall of Berlin ☐

(c) Write an account of the Fall of Berlin.`

Make **at least
six significant,
relevant** points.

1 **Key terms**

Explain briefly but clearly the meaning of each of the following key terms:

★ ● **Superpowers** _____

★ ● **Cold War** _____

● **The Iron Curtain** _____

★ ● **The Truman Doctrine** _____

★ ● **The Marshal Plan** _____

2 On the grid provided:
- Name two superpowers.
- Name two leaders of each superpower.
- Mention two contrasting things about the ways the two superpowers were ruled or organised.

Name of superpower: _____	Name of superpower: _____
Two leaders:	Two leaders:
(i) _____	(i) _____
(ii) _____	(ii) _____
Two contrasts:	
(i) _____ _____	
(ii) _____ _____	

★ **3** Give three reasons why there was division in Europe at the end of World War II.

(i) _____

(ii) _____

(iii) _____

★ **4**

Write about the **Berlin Blockade**:

Marking Scheme

This question was allocated 14 marks in a Junior Certificate examination.

Write at least **eight significant, relevant points**.

★ **5** Write about the **Korean War**:

> **Marking Scheme**
> This question was allocated 14 marks in a Junior Certificate examination.
>
> Write at least **eight significant, relevant points**.

6 The cartoon in Source 1 is about the arms race.

(a) What was the arms race?

(b) What point or message is the cartoon making about the arms race?

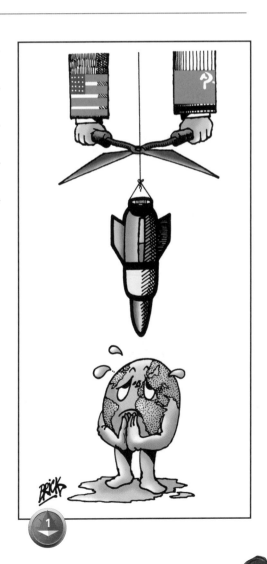

7 Read the four documents in Sources 2, 3, 4 and 5 and answer the questions that follow.

I call upon Chairman Khrushchev to abandon this course of world domination, and to join in an historic effort to end the perilous arms race and to transform the history of man. He has an opportunity now to move the world back from the abyss of destruction – by returning to his government's own words that it had no need to station missiles outside its own territory, and withdrawing these weapons from Cuba.

Source: *New York Times.*

The Berlin air-lift was a considerable achievement but neither side gained anything from the confrontation. The USSR had not gained control of Berlin. The West had no guarantees that land communications would not be cut again. Above all confrontation made both sides even more stubborn.

Nuclear warfare is an utter folly, even from the narrowest point of view of self-interest. To spread ruin, misery and death throughout one's own country as well as that of the enemy is the act of madmen . . . The question every human being must ask is 'can man survive?'

The years passed and changes came about in the life we lived and the people we knew. We also changed. We managed to achieve something, but the problems remained. In the last years we spent in Stavropol I heard Mikhail speak ever more frequently about the difficulties involved in the social development of villages and towns in the region. He also spoke about the difficulties involved in providing the population of the region with foodstuffs and manufactured goods. You see, the region that produced the famous Stavropol wheat, meat and milk suffered from a shortage of other goods.

Source: R. Gorbachev, *I Hope: Reminiscences and reflections*, Harper Collins 1991.

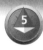

(a) Match each of the documents 2, 3, 4 and 5 with the most appropriate description of it given below. Write the letter 2, 3, 4 or 5 beside each description.

Bertrand Russell, a prominent member of Britain's Campaign for Nuclear Disarmament (CND), speaking about the arms race.	
Raisa, the wife of Mikhail Gorbachev, describing life in the USSR.	
Jack Watson, a historian, writing about the Berlin Blockade.	
A broadcast by an American President in 1962 concerning the arms race.	

★ (b) Why do you think the American President was so concerned that missiles from a foreign power should be stationed in Cuba?

★ (c) Mention one of the problems that Raisa heard her husband speak about when they lived in Stavropol.

★ (d) Documents 2 and 5 refer to two Soviet leaders. If you were a Russian who had lived during the time both Chairman Khrushchev and Mikhail (Gorbachev) ruled the country which of the two leaders would you prefer? Give reasons for your answer (refer to the documents).

(e) Write down one historical fact and one historical opinion given in document 3.

● Fact: _____

● Opinion: _____

8 Name one major incident in the Cold War other than the Berlin Blockade or the Korean War and explain how that incident affected the relationship between the USA and the USSR.

The incident: _____

★ How it affected USA/USSR relationships: _____

9 Putting things in order

Indicate the order in which the six events below happened by writing 1, 2, 3 etc. after them in the boxes provided. Write 1 after the event that happened first, 2 after the event that happened next and so on.

The Cuban Missile Crisis	
The Berlin Blockade	
The Truman Doctrine is announced	

Détente	
The Berlin Wall is built	
The Korean War	

10 Use the grid provided to match each of the terms A to D in Column X with the appropriate item 1 to 4 in Column Y.

Column X		Column Y			
A	Operation Vittles	1	Openness to criticism and debate	A	
B	*Perestroika*	2	The Berlin Airlift, 1948–49	B	
C	*Glasnost*	3	Reconstruction of the Soviet economy	C	
D	Peaceful Co-existence	4	Nikita Khrushchev's proposal for harmony between the USA and the USSR	D	

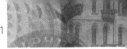

11 Word game and pictures

(a) Name seven Cold War leaders in the word game. The pictures provide the clues to some of those leaders' names.

(b) On the space provided beneath each picture name the country that was ruled by that leader.

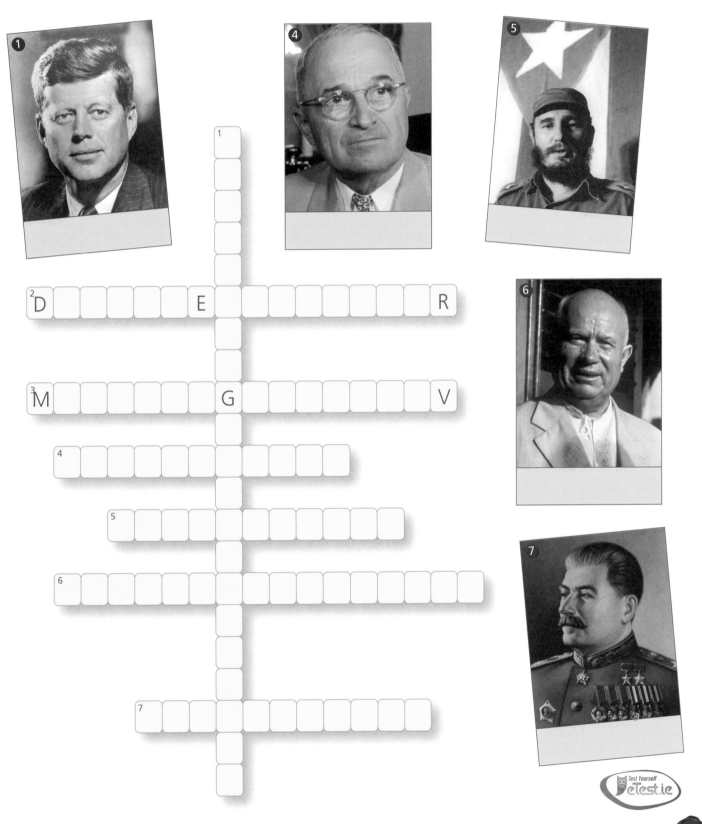

chapter 38 INDIA – THE BIRTH OF A NATION

1 Explain each of the terms given below.

⭐ ● **Colonialism** _____

⭐ ● **Colony** _____

● **Empire** _____

● **Nationalism** _____

⭐ ● **Decolonisation** _____

⭐ **2** Explain briefly the colonial background of a named African or Asian country.

Name the imperial power that colonised the African or Asian country and explain how colonialism affected that country.

3 Complete the passage below by circling the correct alternatives and by filling the blank spaces with words from the Selection Box.

Select twelve relevant words from this box.

India was once called the *Head /Jewel in the Crown* of the British Empire. But British colonialism favoured Britain rather than India. Taxes were *heavy /light*. Indian manufacturing industry was *encouraged /discouraged* and India was used as a source of cheap cotton and other raw _____ for British factories. To make matters worse, most important jobs in the Indian army, civil service and law courts were reserved for *Hindu /British* people. For these reasons, many Indians wanted independence from *Britain /Pakistan*. A political party called the Indian _____ Congress or Congress Party led the call for independence.

Selection Box

- sugar
- National
- Nehru
- 1949
- Rule
- International
- Lucan
- Amritsar
- materials
- Hindu
- salt
- Gandhi
- 1947
- Mountbatten
- spirit
- Muslim
- Government
- soul

In 1915, a man named Mohandas _____ returned from abroad to his native India and became a leader of the Congress Party. Because of his great *humility /wealth*, he became known as 'Mahatma', which means 'great _____'.

In 1919, British forces murdered *379/37* unarmed people in what became known as the _____ Massacre. Gandhi then called for *violent /peaceful* resistance to British rule. He asked people not to buy *Indian /British* goods and not to work for *the British /the Hindus*. He abandoned his campaign when violence broke out.

In 1930, Mahatma led a protest called the _____ March. He led a large crowd to the seashore, where they could make salt without having to pay *taxes /wages* to the British. The British punished Gandhi by *imprisoning /fining* him, but that only made him more popular than ever.

Throughout the 1930s, Gandhi and his Congress Party led a massive movement of *armed /passive* resistance to British rule. In 1935, the British passed an Act of Parliament called the _____ of India Act. This Act gave India a form of limited Home _____. But Gandhi and other Indian *communists /nationalists* were not satisfied. They wanted full independence for India.

By the time World War II ended in *1945/1946*, Britain was *better able /no longer able* to maintain its hold on its massive empire. Britain's last *prime minister /viceroy* to India was Lord Louis _____. He met with Mr _____, the leader of the Congress Party and Mr Mohammed Ali Jinnah, who was the leader of the _____ League. As a result of their negotiations, India was *petitioned /partitioned* and given independence in the year _____.

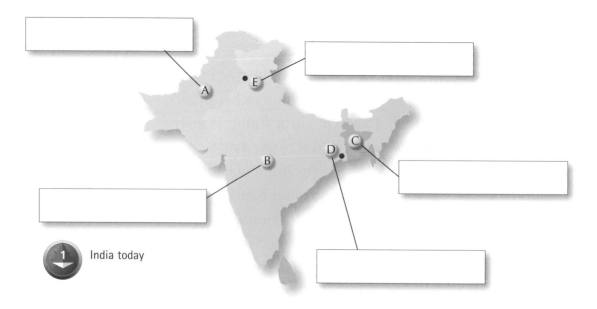

1 India today

4 Examine the map in Source 1. In the boxes provided write in the names of the following places.
- The countries labelled **A**, **B** and **C**
- The Indian city labelled **D**
- The place labelled **E** where a terrible massacre took place in 1919.

Indicate whether people in each of the countries labelled **A**, **B** and **C** are mostly Hindu or mostly Muslim. Write the letter **H** in the middle of a mostly Hindu country and the letter **M** in the middle of a mostly Muslim country.

★ 5 Write an account of the problems that a named newly independent African or Indian country faced after 1945.

Write seven significant, relevant points.

1 Use the headings below to outline four arguments used in favour of increased European Unity between 1945 and 1948.

- **Economics** _____

- **The 'superpowers'** _____

- **Communism** _____

- **Germany** _____

2 Use the grid provided to match each of the terms A–H in Column X with the appropriate term from those listed 1–8 in Column Y.

Column X	
A	Konrad Adenauer
B	European Court of Justice
C	European Social Fund
D	General de Gaulle
E	Denmark
F	Robert Schuman
G	Jean Monnet
H	Treaty of Rome

Column Y	
1	President of France
2	President of the European Parliament
3	German Chancellor
4	French economist
5	Helps poorer EU regions
6	Set up the EEC
7	Established by the Council of Europe
8	Joined the EEC with Ireland and Britain

A	
B	
C	
D	
E	
F	
G	
H	

3 **Putting things in order**

Examine the timeline given in Source 1 below. On the spaces provided:

(a) Name the European treaties that were signed in the years labelled **A**, **B** and **C**.

(b) Name the country or countries that joined the EEC/European Community/EU in each of the years labelled **D**, **E**, **F** and **G**.

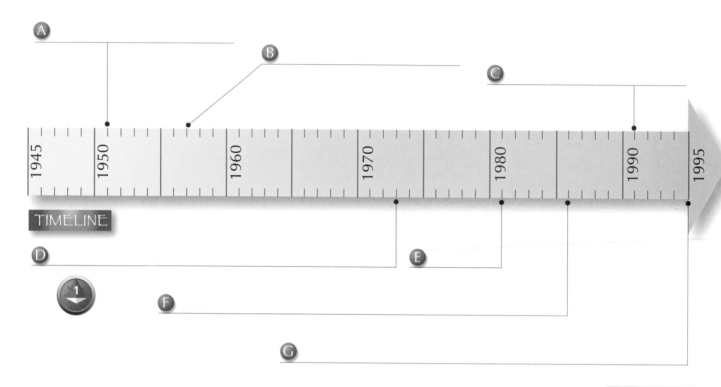

TIMELINE

★ **4** Describe moves that were made towards European Unity between 1945 and the Treaty of Rome.

Use the headings given to guide you.

Write a total of at least seven clear points.

● **The Benelux Agreement** _____

● **The Council of Europe** _____

● **The ECSC** _____

5 The Treaty of Rome

★ (a) What was the purpose of the Treaty of Rome? _____

★ (b) Explain the meaning of the term 'Common Market'. _____

(c) On the map in Source 2, shade in and name the six countries that signed the Treaty of Rome.

★ (d) What was the main advantage to Irish farmers of the Common Agricultural Policy?

(e) Name the fund that was set up to improve living standards in poorer regions of the EEC.

Western Europe in 1957

★ 6 Write an account of the growth of the European Union between the Treaty of Rome and the Treaty of Maastricht.

Based on frequently asked questions.

Write at least eight significant, relevant points.

★ 7 Briefly describe the main **function** or **functions** of each of the following European institutions:

- **The Council of Europe** _____

- **The European Commission** _____

- **The Council of Ministers** _____

- **The European Parliament** _____

8 Complete the passage below by filling in the gaps and circling the correct alternatives.

The Maastricht Treaty

This treaty was signed in the *Belgian / Dutch* city of Maastricht in the year _____. The Treaty gave the European Community the new name of the _____ in order to show that the Community was now a *political/military* as well as an economic union. A new unit of currency called the _____ was introduced from the year _____ onwards. Common *citizenship / membership* was given to everyone who lived in the *nine / twelve / fifteen* countries that then made up the Union. The Maastricht Treaty also expressed the hope that the Union would become *smaller / larger* in the future. It was expected that formerly communist countries in *Northern / Eastern* Europe might apply for membership.

9 Word game

Clues Across:

1 The Council of Europe set up the European _____ of Justice.
3 Main colour in EU flag.
6 EU unit of currency.
7 _____ Monnet.
9 This Market was set up by the Treaty of Rome.
11 Headquarter city of the EU.
13 Schuman and Monnet drew up the Schuman _____ in 1950.

Clues Down:

2 The treaty that gave rise to the EEC was signed in this city.
4 A 'Benelux' State.
5 Robert Schuman spent his youth there.
8 The Council of _____ is the main decision-making body of the EU.
10 The Treaty of 1991.
12 Joined the European Community in 1986.

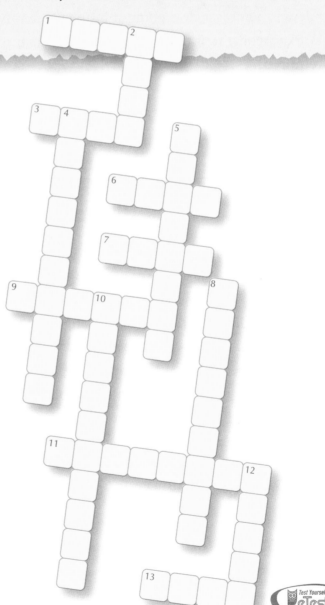

The layout of Junior Certificate Examination papers

In order to do well in your Junior Certificate History examination, it is very important that you manage your examination correctly. To do this, you will need to know the layout of the examination paper.

Tips and tactics

- **Read** each question very carefully. Make sure you understand the questions that you intend to answer.
- Always **answer 'to the point'** of the questions asked.
- **Lengths of answers** should relate to the numbers of marks carried by questions. A question carrying two marks, for example, may usually be answered by a single sentence. A question carrying 14 marks might require at least seven **significant, relevant points**. (A significant, relevant point is a clear point of history that answers the question being asked.)
- Work carefully to a **timetable** within the exam so that you make time to **answer all the questions required**.

The Higher Level examination

The Higher Level examination:

- Contains six different sections.
- Carries 180 marks.
- Is allocated 2 hours and 30 minutes.

Section 1 – Picture sources (15 marks)

This section usually features three or four historical pictures. These are accompanied by some questions that relate to the pictures themselves and some questions that relate to what you have learned in your History course. Most questions carry one or two marks. Each question usually requires a short answer of only a few words or a sentence or two.

Section 2 – Document sources (15 marks)

This section typically contains two historical documents. They are accompanied by some questions that relate to the documents themselves and some questions that relate to what you have learned in your History course. Most questions carry one or two marks and each usually requires a short answer of a few words or a sentence or two.

Section 3 – Short-answer questions (20 marks)

There will be **twenty questions** from all parts of your History course. You will be asked to **answer ten** of these questions. Each question carries two marks and requires a short answer that contains one or two historical facts.

If you have time, answer more than ten of these questions. You will be marked for your ten best answers.

Section 4 – People in history (40 marks)

There are **two parts** in this section:

- **Part A** will give a list of three people from the earlier part of your History course (usually up to Chapter 10 of your Textbook). You must write on **one** of those three people.

- **Part B** will give a list of three people from the later part of your History course (usually from Chapter 11 onwards). You must write on **one** of those three people.

Try to write at least ten significant, relevant points on each person that you write about.

Section 5 – Questions on a particular topic (30 marks)

This section usually focuses on a topic that you studied in **second year** (from about Chapter 8 to Chapter 20 of your Textbook). It includes one or more pictorial or document sources. A variety of questions are asked. Some relate to the **sources**. Others (which usually carry more marks) relate to **what you have learned** in your History course.

Section 6 – mostly from Third Year (60 marks)

This is the **most important section** of the examination. It has **four parts** labelled **A**, **B**, **C** and **D**, each of which carries 30 marks. You must answer **any two** parts.

- **Part A** focuses on a topic that you will have learned in **first** or **second year**.

- **Parts B, C and D** focus on topics that you will have learned in **third year** (from Chapter 21 onwards of your Textbook).

Each part contains several questions, some of which can carry as many as 14 marks.

Timing

It is very important to use a **timetable** that suits **you** for answering questions in the examination. Below is one **possible** timetable.

Reading etc.*	10 minutes
Section 1	15 minutes
Section 2	15 minutes
Section 3	15 minutes
Section 4	30 minutes
Section 5	25 minutes
Section 6	40 minutes
Total:	**150 minutes**

(Two hours and 30 minutes)

* **Read** the examination paper. **Choose** the questions that you will do. **Highlight** the key words in these questions.

The Ordinary Level examination

The Ordinary Level examination:
- Contains four different sections.
- Carries 180 marks.
- Is allocated 1 hour and 30 minutes.

Section 1 - Picture sources (35 marks)

This section usually features three or four historical pictures. These are accompanied by some questions that relate to the pictures themselves and some questions that relate to what you have learned in your History course. Most questions carry two to four marks. Each usually requires only a short answer of a few words or a sentence or two.

Section 2 - Document sources (35 marks)

This section typically contains two historical documents. They are accompanied by some questions that relate to the documents themselves and some questions that relate to what you have learned in your History course. Most questions carry two to four marks and each usually requires only a short answer of a few words or a sentence or two.

Section 3 - Short-answer questions (60 marks)

There will be **twenty questions** from all parts of your History course. You will be asked to **answer ten** of these questions. Each question carries six marks and requires a short answer that contains one or two historical facts.

If you have time, answer more than ten of these questions. You will be marked for your ten best answers.

Section 4 - People in history (50 marks)

There are **two parts** in this section:
- **Part A** will give a list of three people from the earlier part of your History course (usually up to Chapter 10 of your Textbook). You must write on **one** of those three people.
- **Part B** will give a list of three people from the later part of your History course (usually from Chapter 11 onwards). You must write on **one** of those three people.

Try to write at least ten significant, relevant points on each person in history that you write about.

Timing

It is very important that you have a **timetable** that suits **you** for answering questions in the examination.
Below is one **possible** timetable.

Reading etc.*	5 minutes
Section 1	15 minutes
Section 2	20 minutes
Section 3	20 minutes
Section 4	30 minutes
Total:	**90 minutes**

(1 hour and 30 minutes)

* **Read** the examination paper, **choose** the questions in Section 4 that you will do. **Highlight** the key words in these questions.

Exam-speak

Below is a list of the **command words** that you are likely to find in your Junior Certificate History examination. It is important that you understand and write 'to the point' of these command words in your examination.

- **Name** . . .
- **Identify*** . . .
 (*usually in relation to a map, picture or other document)

Name only. Do not describe.

- **Mention** . . .

Name and/or refer very briefly to the subject being asked. Answer in one sentence.

- **Describe** . . .
- **Write an account of** . . .
- **Write about** . . .
- **Write a paragraph on** . . .

Write a **descriptive account**.

- **Explain why** . . .
- **State three reasons for** . . .
- **Mention one factor that gave rise to** . . .

Refer to the **causes** of some historic event.

- **Describe the consequences of** . . .
- **Write on the impact of** . . .
- **Mention two effects of** . . .

Refer to the **results** of some historic event.

- **Describe three changes** . . .
- **Mention four developments** . . .

Describe **change over time**.

- **According to the document** . . .
- **From evidence in the photograph** . . .
- **What does the extract say** . . .?

The answers are **in the documents/sources** provided with the questions.

- **Do you think that** . . .?
- **Do you agree that** . . .?
- **What do you think?**

You must usually give **reasons for** your opinions.
The reasons might be based:
(a) on **documents** that accompany the questions, or
(b) on your own **knowledge** of History.

Some **People in History** questions provide 'HINTS' that they say 'you may use' to help you in your answer.

You may **use or ignore** those hints in your answer.

> How long should my answers be?

- The length of your answer should depend on the **number of marks** allocated to the question that you are answering.
- As a general rule, write **at least one significant, relevant point** for **every two marks** allocated to a question.
- Some (Section 3) **short answer questions** require answers that contain **two historical facts**.